THIRD FLOOR

LONG G...

TITIAN ROOM

VERONESE ROOM

GOTHIC ROOM

STAIR HALL

SECOND FLOOR

LITTLE SALON

SHORT GALLERY

TAPESTRY ROOM

RAPHAEL ROOM

ELEVATOR

DUTCH ROOM

EARLY ITALIAN ROOM

STAIR HALL

FIRST FLOOR

YELLOW ROOM

SPANISH CHAPEL

CHINESE LOGGIA

CAFE

ENTRANCE

SPANISH CLOISTER

BLUE ROOM

EAST CLOISTER

MUSEUM SHOP

MEN'S ROOM

NORTH CLOISTER

ELEVATOR

WOMEN'S ROOM

EXIT

COURT

COAT ROOM

MACKNIGHT ROOM

SPECIAL EXHIBITION GALLERY

WEST CLOISTER

HANDICAPPED ACCESSIBLE RESTROOM

N

GUIDE TO THE COLLECTION

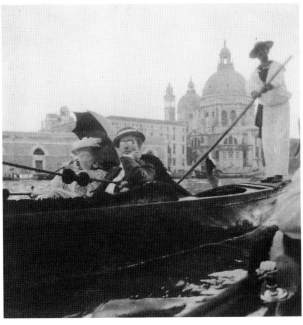

Isabella Stewart Gardner in Venice, accompanied by Gaillard Lapsley, ca. 1894.

ISABELLA STEWART GARDNER MUSEUM

GUIDE

TO THE

COLLECTION

THIRD EDITION

ISABELLA STEWART GARDNER MUSEUM

BOSTON, MASSACHUSETTS

Published by the Trustees
of the Isabella Stewart Gardner Museum
Two Palace Road, Boston, Massachusetts 02115
© 1997 Isabella Stewart Gardner Museum, Boston
Third Edition

ISBN 0-9648475-6-6

CONTENTS

NOTE TO THE READER

This *Guide* is intended for visitors who wish to locate the more renowned artworks and to identify those objects most often inquired about in the Isabella Stewart Gardner Museum. The collection contains a large number of works that are familiar to students of art and that are the subjects of many published discussions. Other objects have been included for description in this guide because they reflect the taste of Isabella Gardner and often pique the curiosity of viewers. Visitors are invited to study and enjoy the collection according to their own interests.

Whenever possible, the name of the artist is given, but at times this is surprisingly difficult to determine. Often there is no signature; sometimes there may be grounds for doubting the validity of the signature. The identity of some artists will probably always be unknown; in other cases, the artist is identified by an accepted inscription or by clear documentation. The collection also includes works the origins of which—date, artist, and place—are warmly debated. The results of these controversies may effect changes in prestige and market value, but they have no effect on the intrinsic quality of the objects themselves.

An object attributed to the "studio of" or "workshop of" a known artist is by one who probably was a close associate. A less personal and direct relationship, but one close in time, is indicated as "influenced by," while "style of" covers those further removed in time. "After" refers to a work by an unknown artist after a known and definitely attributed original.

In this third edition of the *Guide*, the selection of objects for consideration and the revised attributions reflect the stated interests of our visitors, the current scholarship in our updated curatorial records, and the status of ongoing research. A more comprehensive narrative introduction to Isabella Stewart Gardner, her collection, the building of Fenway Court, and the installation of the galleries is presented in *The Isabella Stewart*

Gardner Museum: A Companion Guide and History (1995) by Hilliard T. Goldfarb.

Some visitors will likely take greatest pleasure from the whole appearance of the museum, the relation of the works of art to their setting, and to the changing colors and fragrances of the flowering Court. Together, these make up Isabella Gardner's composition, an embodiment of the concept of a museum as a grand house where people might have lived for generations surrounded by things that they cherished.

Her architectural predilection was for the Italian Early Renaissance, and her vision of a museum was a Venetian palace of the fifteenth century, with galleries open on a courtyard in bloom. The dream became reality, planned in complete detail by Isabella Gardner and erected under her constant supervision. Before the architectural drawings were finished, she had already decided where each imported pillar, doorway, arch, stone carving, or other structural member would be placed. The building was finished in 1902; it had already been incorporated as a museum in 1900. Upon her death in 1924, her will provided for the permanent maintenance of Fenway Court in its original arrangement.

This arrangement, designed to draw the visitor into a personally experienced relationship with the works of art and their context, was not intended to facilitate locating the objects considered most important. Often such objects are not given conspicuous positions, and they are placed discreetly in galleries. The result is a set of rooms that have a personal, informal character.

In its principal holdings, the catalogued collection consists of approximately 320 paintings, 385 sculptures, 320 prints and drawings, 400 pieces of furniture, 340 textiles, 230 objects of ceramic and glass, and over 400 objects of other kinds, without an enumeration of manuscripts and rare books or of architectural elements set into the building.

Mrs. Gardner in Venice, by Anders Zorn.

ISABELLA STEWART GARDNER:
A BIOGRAPHICAL SKETCH

Isabella Stewart was born in New York City on April 14, 1840, the child of David Stewart, of Scottish descent, who made his fortune in the Irish linen trade and later in mining investments, and of Adelia Smith, descendant of Richard Smith, an Englishman who had settled in Boston in 1650. She was named after her paternal grandmother, herself a remarkable woman and successful farmer. Isabella Stewart's first connection with Boston came through her schooling between 1856 and 1858 in Paris, where a friendship with her schoolmate Julia Gardner led to marriage with Julia's elder brother, John Lowell Gardner, in 1860. The young couple established themselves in Boston, where her independence of manner and thought excited a good deal of comment.

The birth of their son in June 1863 proved to be a short-lived joy. Isabella Gardner lavished great warmth and attention on the boy, and when he died two years later, she was crushed. During the two years that followed the boy's death, she endured depression and illness. At a doctor's suggestion, Jack Gardner took his wife to Europe, her condition so poor that she had to be carried aboard the ship on a mattress. They traveled in Scandinavia and Russia and to Vienna and Paris. Within a few months, she returned home in health and in good spirits, with the zest for life and energetic intellectual curiosity that had earlier characterized her. She soon became one of the most remarked-upon members of Boston society.

In 1874, Jack and Isabella Gardner went abroad again, visiting the Middle East, Central Europe, and Paris, the forerunner to future travels to Europe with increasing frequency. In a small way, she had begun to acquire minor works of art, without thought of forming a collection; but in 1885, in Venice, Isabella Gardner began to feel the power of the great masters of the

Italian Renaissance. It took time to bring her to decision; it was not until 1888, in Seville, that she bought her first old master, a Madonna by Francisco de Zurbarán (now catalogued as from his studio). It hangs in the Spanish Chapel, on the ground floor (see p. 20). At an irregular but accelerating pace, especially after she received her father's inheritance in 1891, she deliberately became a collector of fine art.

Throughout the 1880s, under the mentorship of Harvard Professor Charles Eliot Norton, himself a former student of John Ruskin, Isabella Gardner began acquiring rare books and manuscripts, including early editions of Dante and a selection of Venetian and French sixteenth-century publications. She also became an early supporter of the Boston Symphony Orchestra.

A friendship that was to prove significant began at this time. Like many fashionable Bostonians, Isabella Gardner had been attending lectures of famous Harvard teachers, and it was perhaps in Professor Norton's art history class that she met the charming and brilliant young man, Bernard Berenson. He made a strong impression on her, and after his graduation in 1887, she was one of those who helped him go abroad. Devoting himself to the study of Italian art and the correction of attributions, he soon became recognized as a leading connoisseur. From 1894 onward, Isabella Gardner relied heavily on his advice and assistance in the acquisition of important works of art. She also was guided by others, including Fernand Robert, Ralph Curtis, Anders Zorn, Henry Adams, Joseph Lindon Smith, and John Singer Sargent. Gardner's animated correspondence with Berenson and other contemporaries, however, reveals an individual and increasingly sophisticated connoisseur's mind, and she was quite capable of acting independently and decisively in the acquisition of her art treasures. In 1896, with the acquisition of works by Rembrandt, Titian, Velázquez, and Cellini, she began writing of her intention to create a museum for the public.

Two traits in Isabella Gardner help to reveal her character: her love of music and her perceptive and amiable patronage of talent of every sort. Conductors, composers, players, singers,

painters, sculptors, writers, and scholars were all beneficiaries of her wealth of spirit and money. In a variety of quiet but effective ways, she furthered many careers. She also sought out emerging young talents in the United States, including the painters Dennis Miller Bunker and Thomas Dewing and the musicians Charles Loeffler and Pablo Casals. She was on close personal terms with Henry James, Anders Zorn, John Singer Sargent, and Nellie Melba, among many other artists of the age.

At the end of December 1898, John Lowell Gardner died, leaving a trust of which a portion was to become the endowment for the Gardner Museum. His death seemed to have shocked her into an awareness that she, at 58, was no longer young, and she began furiously to work toward the realization of the museum that she and her husband had planned. Already in 1897, the two had traveled to Europe to acquire some of the architectural elements that would be used in Fenway Court. A few weeks after her husband's funeral, she bought land in the recently filled Fens, an area that the two had discussed as a possible site. While the foundation piles for Fenway Court were being driven, she left for Europe to look for more columns, capitals, arches, ironwork, fireplaces, staircases, and fountains, among other architectural elements, to incorporate into the building. At the same time, she continued to add to her collection of masterpieces. She returned home in December 1899 to supervise construction. The plan was often modified by her, and every detail was required to have her specific approval.

The seal that Isabella Gardner designed for her museum was characteristic: a shield bearing a phoenix, symbol of immortality, and the frank motto *C'est mon plaisir* (It is my pleasure). It was part of her pleasure to keep her plans for the museum wholly to herself. By December 1901, the building was essentially finished, some of the sculpture was in place, and plants were growing in the Court. During the following year, the primary focus of activity was the installation of the collection and furnishings according to her specifications. Meanwhile, public curiosity grew.

The climax came on New Year's Night 1903, the official opening. Her guests listened to a concert of Bach, Mozart, Chausson, and Schumann played by fifty members of the Boston Symphony Orchestra under Wilhelm Gericke, in a two-story concert hall the upper half of which is now the Tapestry Room. Then the Court doors were opened, and the guests were admitted to a spectacle that was strange indeed in mid-winter Boston—the balconies were hung with lanterns, numberless candles flickered beyond the archways and windows, fragrance and color spilled from the masses of flowering plants, and the fountains murmured softly. William James, who attended the opening, wrote to Gardner, "The aesthetic perfection of all things . . . seemed to have a peculiar effect on the company, making them quiet and docile and self-forgetful and kind, as if they had become as children. . . . Quite in the line of a Gospel miracle!"

The first public opening was a few weeks later, on February 23, 1903, and from then on Fenway Court was periodically opened to the public, on a limited schedule and with an admittance fee. Isabella Gardner lived quietly in private quarters on the fourth floor of the museum, giving only an occasional large party, but she enjoyed entertaining distinguished friends she had met over the years, and she continued to buy works of art.

Shortly after Christmas in 1919, she suffered a stroke and thereafter never again walked. Answering a letter from her old friend Count Hans Coudenhove in 1922 (she was then 82), she wrote:

I haven't a horse or anything now, but I am trying to keep up my courage. I'm quite an invalid, but cheerful to the last degree. I think my mind is all right and I live on it. I keep up a lot of thinking, and am really very much alive. I live in one house, everything else having been sold. This house is very nice, very comfortable, and rather jolly. It is on the outskirts of Boston, not in the country. I have filled it with pictures and works of art, really good things I think, and if there are any

A Biographical Sketch

clever people I see them. I really lead an interesting life. I have music, and both young and old friends. The appropriately old are too old—they seem to have given up the world. Not so I, and I even shove some of the young ones rather close.

Isabella Stewart Gardner died a year and a half later, on July 17, 1924, and was buried in Mount Auburn Cemetery, Cambridge, in the Gardner tomb, between her husband and her son. Her true memorial is this museum. In advance of such renowned collectors as J. P. Morgan, Henry Clay Frick, and Henry E. Huntington, Gardner established the idea in the United States of housing great artworks in a palatial setting that had been created, as she bequeathed it in her will, as a museum "for the education and enjoyment of the public forever."

Yellow Room

The *Bronze Cases* are filled with **autographs** and **photographs** of musicians, friends, acquaintances, and persons admired by Isabella Gardner. There are **letters** from Wilhelm Gericke, Charles Martin Loeffler, Nellie Melba, Pierre Monteux, Karl Muck, Francesco Paolo Tosti, Anna Pavlowa, and Amherst Webber (whose operetta *Fiorella* had its premiere in this building). The autographed photographs include those from Fritz Kreisler, Jules Massenet, Ignace Paderewski, Johann Strauss, Johannes Brahms, and Eugène Ysaÿe. Not connected with Isabella Gardner, but collected by her, are letters and autographs from Beethoven, Berlioz, Liszt, Mendelssohn, Saint-Saëns, Richard Strauss, and Wagner. There are also: a copy of **Beethoven's death mask**; **casts** of Loeffler's hand (with violin neck), Arthur Foote's hand, and Liszt's hand (holding another); a medal of Brahms by Anton **Scharff** (Austrian, 1845–1903); a leaf of a signed Tchaikovsky **manuscript** score; a pencil sketch of *Jascha Heifetz* by John Singer **Sargent** (American, 1856–1925); an ink sketch of *Loeffler* by Anders **Zorn** (Swedish, 1860–1920); a brass **die** of Liszt's autograph and a small vessel containing a lock of his hair; and a 19th-century Japanese *Shō* (mouth organ).

AROUND THE ROOM: **settee**, five **side chairs** and two **armchairs** (Italian, first half of the 19th c.) with caned seats and backs in a pastiche of the styles of Adam and Louis XVI (arms), Louis XV (legs and backs), and Hepplewhite (seats).

➤ FROM LEFT TO RIGHT, STARTING TO THE RIGHT OF THE DOOR:

WEST WALL:

A Lady in Yellow, 1888, by Thomas Wilmer **Dewing** (American, 1851–1938), purchased from the artist, 1888, through Dennis Miller Bunker. Considered by some to be Dewing's masterpiece, it received the silver medal at the Exposition Universelle in Paris in 1889. The frame is original, designed by the artist's colleague, the architect Stanford White (American, 1853–1906).

The Yellow Room, along the West Wall. Thomas Dewing's *A Lady in Yellow* is on the left; Rossetti's *Love's Greeting* is on the far right.

On a Terrace, ca. 1845/55, by Narcisse-Virgile **Diaz de la Peña** (Spanish-French, 1807–1876), purchased from Leonard & Co., Boston, 1876.

Charles Martin Loeffler, 1903, by **Sargent**, painted at Fenway Court and given to Isabella Gardner on April 14, 1903, her birthday.

Lowland Pastures, by Félix-François-Georges-Philibert **Ziem** (Croatian-French, 1822–1911).

Love's Greeting, by Dante Gabriel **Rossetti** (English, 1828–1882). Based on the frontispiece to Rossetti's first book of translations, *The Early Italian Poets from Ciullo d'Alcamo to Dante Alighieri translated by D. G. Rossetti* (1861) and purchased from the estate of Frederick R. Leyland, London, 1892.

NORTH WALL:

BELOW THE MIRROR: **chest of drawers** (Italian, 19th c.), decorated with painted landscapes and marine scenes. It supports one of the *Bronze Cases* described above.

EAST WALL:

Nocturne, Blue and Silver: Battersea Reach, ca. 1872/78, by James A. McNeill **Whistler** (American, 1834–1903), purchased from the artist, Paris, 1895.

Mme Gaujelin, 1867, by Hilaire-Germain-Edgar **Degas** (French, 1834–1917), purchased from Eugene Glaezner & Co., New York, 1904, on Berenson's recommendation. The sitter, Josèphine Gaujelin, was a dancer at the Opéra and an actor at the Théâtre du Gymnase.

Harmony in Blue and Silver: Trouville, 1865, by **Whistler**, purchased from the artist, Paris, 1892. The figure in the foreground is the French painter Gustave Courbet.

The stone arched **window** is composed of Northern Italian architectural fragments, 14th or 15th century.

SOUTH WALL:

Garden of Poppies, pastel on paper, by John Appleton **Brown** (American, 1844–1902), purchased from Doll & Richards, Boston, 1891. The garden is that of the poet Celia Thaxter, on the Isle of Shoals, New Hampshire.

The Terrace, St. Tropez, 1904, by Henri **Matisse** (French, 1869–1954). Depicted is the artist's wife at La Hune, the villa of the painter Paul Signac. The first canvas by Matisse to enter a U.S. museum, it was a gift from the Byzantine archaeologist and scholar Thomas Whittemore.

BELOW, ON THE DOOR: TOP, LEFT: *Isabella of Portugal,* engraved by Pieter **De Iode II** (Flemish, 1606–ca. 1674), after Titian, AND RIGHT: *King John of England,* engraved by George **Vertue** (English; 1684–1752). BOTTOM: *Mrs. Gardner at Fenway Court,* 1903, watercolor on paper, by **Sargent**.

TO THE RIGHT: ABOVE: *The Croquet Party,* ca. 1913, AND BELOW: *Charleston,* ca. 1913/14, both by Martin **Mower** (American, 1870–1960). The former was a gift of the artist, 1913; the latter sold for one day's receipts at Fenway Court.

AROUND THE CORNER, IN THE SMALL SHOWCASE: viola d'amore, ca. 1770s, by Tomaso **Eberle** (Neapolitan, 1760–1792), gift of Charles Martin Loeffler to Isabella Gardner on her birthday in

1903 (see the Sargent portrait of him in this room). Also in the case is a **mandolin** (Italian, 18th c.) and a brocaded **chasuble** (Italian, 18th c.).

ABOVE THE CASE: TOP: *Gaston de Foix*, ca. 1894, watercolor on paper, by Joseph Lindon **Smith** (American, 1863–1950). The painting depicts a fragment of an unfinished tomb commissioned of Agostino Busti ("Il Bambaia") by François I for a chivalrous count who died in 1512. BOTTOM: *In the Dressing Room,* 1910, pastel on canvas, by Louis **Kronberg** (American, 1872–1965).

TO THE FAR RIGHT: *A Cottage by a Ford*, pastel on paper, by Constant **Troyon** (French, 1810–1865). BELOW: *The Roman Tower, Andernach*, probably 1817, watercolor on paper, by Joseph Mallord William **Turner** (English, 1775–1851), purchased from Ayscough Fawkes's Farnley Hall collection, London, 1890.

SOUTH WALL:

This **cabinet**, along with those in the Short Gallery (see p. 64) and the Long Gallery (see p. 112), is made from old wooden panels and moldings that were largely acquired from the Émile Peyre collection in Paris in 1897. They are in the Gothic style of the 14th and 15th centuries.

ON TOP OF THE CABINET, LEFT TO RIGHT: *Sang de boeuf* **vase** (Chinese, ca. 1821–50); small gilt **statue** of Gautama Buddha (Chinese, 18th c.); black porcelain **vase** (Chinese, 19th c.). ON THE WALL BEHIND THEM: Spanish **embroidery** dating to the middle of the 18th century.

INSIDE THE CABINET: assortment of Chinese, English, French, German, Italian, Persian, and Turkish ceramics. The gilt **coffeepot** on the second shelf belongs to the set in the Veronese Room (see p. 95). Throughout the case are eighteen pieces of Sèvres **porcelain** that bear the marks of the painter Yvernel and the year 1769. There are also twenty-four pieces of **Worcester Armorial China** (English, Chamberlain & Co., 1789–1840), inscribed on the scroll: *Coignoies toy mesme* (old

French for "Know Thyself"). Both the porcelain and china were purchased from the Mary J. Morgan collection, New York, 1886.

WEST WALL, TO THE LEFT OF THE DOOR:

TOP: *Mary Queen of Scots under Confinement*, 1793, mezzotint, by William **Ward** (English, 1766–1826), after Robert Fulton. MIDDLE: *Mary Queen of Scots Leaving Scotland*, 1794, mezzotint, by Francesco **Bartolozzi** (Italian, 1727–1815), after a design by Richard Westall. BOTTOM: *Mary Queen of Scots*, 1779, engraving, by **Bartolozzi**, after Federico Zuccheri.

ABOVE THE DOOR: *Apartments of the Chief Priest, Kyoto*, 1900, by Joseph Lindon **Smith**.

➤ RETURNING THROUGH THE ENTRANCE LOBBY, TO THE LEFT:

Spanish Chapel

ON THE WALL ABOVE THE ALTAR: *The Virgin of Mercy*, ca. 1630–35, from the **studio of Francisco de Zurbarán** (Spanish, 1598–1664), purchased from Jacopo Lopez Cepero, Seville, 1888. The canvas was trimmed down before the date of purchase.

The textile of the **altar frontal** is 16th-century Spanish drawn-work, of hard-twisted heavy linen thread; a band of Italian needlepoint lace trimming the **superfrontal** is 16th-century reticella work. ON THE ALTAR: six bronze **candlesticks** (Italian, probably modern, in the style of the 17th c.) and a wood and bronze **crucifix** (Venetian, 18th c.).

ON THE FLOOR: **tomb figure** of a knight, ca. 1498–1500, alabaster, purchased from Emil Pares, Madrid, 1906. A Castilian work, probably from the city of Salamanca. It has been suggested that it represents a member of the Maldonado family.

SET INTO THE WINDOW: several painted **glass panels** and **medallions**. The center roundel is of *Saint Martin and the Beggar*

(French, 16th c.). The lower left one shows *Saint Benedict Lying in the Briars* (German, 16th c.), one of a series designed by **Dürer.**

ABOVE THE WINDOW: **cherub heads** and ornamental **carvings** (Spanish Colonial, Panama). Removed from the cathedral in Panama City in 1872, when it was in ruins. Given to Isabella Gardner by Theodore Dwight of the Boston Symphony Orchestra in 1915.

TO THE LEFT: painted wood **figure** of a standing bishop (Netherlandish or German, 15th c.).

BEHIND THE RAILING: **cross** inlaid with mother-of-pearl (possibly Venetian, 17th c.), purchased from Antonio Carrer, Venice, 1893.

OPPOSITE THE ALTAR: marble **relief** of two crowned female saints. The one with the lamb is *Saint Agnes* (Neapolitan, second half of the 14th c.). The marble itself was once part of a 3rd-century Roman sarcophagus; a fragment of the original carving remains on the back.

The column **capitals** are Spanish-Romanesque, 15th century.

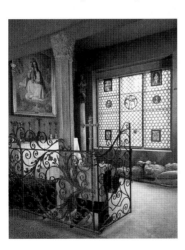

The Spanish Chapel, looking toward *The Virgin of Mercy*, from the studio of Francisco de Zurbarán.

Spanish Cloister

ON OPPOSITE SIDES OF THE DOORWAY (BEHIND, AS ONE ENTERS): two limestone **reliefs**, *Entry into Jerusalem* and *Two Kings or Elders of the Apocalypse* (French-Romanesque, middle of the 13th c.; partially restored in the late 19th c.), from church of Notre-Dame-de-la-Couldre at Parthenay, in Poitou. Purchased in 1916 with the Bordeaux portal (also in this room) from Demotte in Paris at the recommendation of Bernard Berenson.

The wrought-iron **grills**, **gates**, and **railings**, in the Cloisters, Spanish Chapel and elsewhere in the Stair Halls are Italian and Spanish, 16th–19th century. The blue **tiles** comprising the floor were purchased in 1914 from the Grueby Faience and Tile Company. For other American Arts and Crafts period tile floors, see the Second and Third Floor Hallways, the Dutch Room, and the Gothic Room.

COVERING THE EAST AND WEST WALLS: **tiles** (Mexican, 17th c.), taken from the Church of San Augustin, Atlixco, in Puebla, Mexico. They were acquired through the painter Dodge Macknight in 1909 and arranged here by Isabella Gardner in

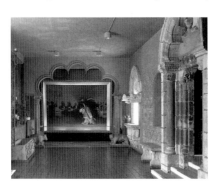

The Spanish Cloister, looking toward John Singer Sargent's *El Jaleo.*

1914. Along the West Wall: marble **sarcophagus** (Roman, in the style of the 5th or 6th c., possibly modern construction). Along the East Wall: two marble **sarcophagi** (Roman, 3rd c.).

Sandstone **portal** (French, late 12th c.), once the entrance to a private house in La Réole, near Bordeaux.

The second window: elaborately carved stone **window arch** (possibly French, late 15th c.). In the window are brass and copper water **pitchers** (possibly Italian, 18th c.).

The Alcove:

El Jaleo, 1882, by John Singer **Sargent** (American, 1856–1925). Based on drawings that he had made in Spain in 1879 and named for an Andalusian dance, *El Jaleo* is considered by many to be one of Sargent's greatest early achievements. A gift of Hon. T. Jefferson Coolidge in 1914, when this entire gallery was constructed as a setting for it.

Framing the alcove: Moorish arch, designed for this setting, supported by late Medieval Italian **columns** with animal bases. Around the mirror at the left: five pieces of wooden **inscription panels** (Egyptian, 13th–14th c.). They once decorated the home of a pious Muslim. On the window ledge to the right: Turkish **tile** (Iznik, 16th c.), part of a wall revetment.

Other Islamic tiles decorate the niche, including, above the window: Persian **luster tile** from a Mihrab or prayer niche (Kashan, 13th c.). The *thuluth* letters are from verses 187 and 188 of *Sura 3* of the *Qu'ran*, marveling at the creation of the Heavens and the Earth and the succession of night and day.

The wrought-iron **stand** and pottery **basin** are Spanish, 16th and 18th–19th century, respectively. The **chairs** and the terracotta **stools** (Italian) are modern. The large terra-cotta **jar** is Hispano-Moresque, 14th or 15th century.

➤ AT THE EAST TOWARD THE LARGE GLASS WINDOWS:

Originally, the loggia windows opened out to create an indoor porch. When the windows were sealed to protect artworks in the building, some of the outdoor sculpture was placed on the windowsill.

Chinese Loggia

TURNING TO THE LEFT: three rectangular **cinerary urns**. The one made of sandstone is probably Italian, 15th century; the two marble ones are Roman, Imperial period.

AT THE END: limestone **Madonna and Child** (French, in the style of the early 14th c.). Purchased in 1919, debate over the authenticity of this piece began a few years later in a 1923 inquiry against the Paris dealer, Demotte, from whom it had been acquired. BELOW: Corinthian **capital** (Roman, 2nd c.). ABOVE THE MADONNA: stone **tablet**, *Patrician Family at Prayer* (Westphalian, ca. 1600). FLANKING THE MADONNA: two marble **columns** with Hispano-Moresque **capitals** (10th c. or later).

HANGING IN THE WINDOW TO THE RIGHT: **stained-glass panel**, made of fragments from the windows of Rheims Cathedral (13th c.). Its windows were destroyed by a German bombardment in August 1914; soldiers collected fragments of the colored glass, sometimes having them set into rings. These 105 pieces were compiled into a panel by Chester Howell of Dorchester, Massachusetts, an ambulance driver with the American Field Service. He presented it to Isabella Gardner in 1920 through one of the AFS directors, Henry Davis Sleeper.

ALONG THE WINDOWSILL, LEFT TO RIGHT: **statuary**: *Woman in the Costume of the Theater* (Roman, 3rd c.); *Herm of Dionysos* (Graeco-Roman, Archaistic version of a work of the 5th c. B.C.): *Eros Apoxyomenos* or *Funerary Statue of a Boy* (Graeco-Roman, 3rd c.); *Torso of a Silvanus or a Youthful Male Season* (Graeco-Roman, 2nd or 3rd c.); *Funerary Statue of a Boy* (Roman, perhaps of the Antonine period); *Torso and Right Leg of*

Dionysos or Apollo (Graeco-Roman, ca. 50 B.C.); *Bowl with Griffin Heads* (Roman, 1st c.).

OPPOSITE THE STEPS: door to the Monks Garden flanked by a **head of a Roman** and **veiled head of a Roman woman** (Roman, 1st c. B.C.–1st c. A.D.), both set on garden **herms**.

CONTINUING ALONG THE WINDOWSILL TO THE RIGHT OF THE DOORS: rectangular **cinerary urn** (Roman, 117–138); *Torso of Dionysos* (Graeco-Roman, 140–190); circular **cinerarium** (Roman, 60–90); rectangular **cinerary urn** (Roman, late Julio-Claudian or early Flavian period); and *Torso of a Man* (Graeco-Roman, copy of a work of ca. 440 B.C. or earlier). HANGING IN THE BAY WINDOW: bronze **temple bell** (Japanese, 19th c.).

TO THE RIGHT OF THE BELL: **Kuan-Yin** (Chinese, 11–12th c.), purchased from Parish-Watson, New York, 1919. Kuan-Yin is the bodhisattva Avalokitésvara, the deity of Compassion, depicted here in the posture of *mahāraja-lalitāsana*, or "royal ease." On the headdress appears the Dhyāni Buddha called Amitāba.

FREESTANDING ON THE RIGHT AS ONE HEADS TOWARD THE RAMP: carved limestone **votive stele** (Chinese, Eastern Wei dynasty, dated 543 A.D.), purchased from Victor Goloubew, Paris, 1914, through Berenson. It depicts in high relief on the front a Buddha with his hands in the positions symbolic of "absence of fear" and of "charity." At his left and right appear two monks and two bodhisattvas. On the base is an inscription with the names of the seventy-eight donors and the date of the dedication. On the back, a scene from the *Lotus Sūtra* (chapter 11) depicts the meeting of Sākyamuni and Prabhūtaratna.

➤ TURNING BACK ACROSS THE SPANISH CLOISTER, THROUGH THE PORTAL (P. 23):

East Cloister

AT THE SOUTH END (TO THE LEFT AS ONE ENTERS): **fountain**, assembled from odd pieces of Italian stone carving. The **sarcophagus** with strigilar carving is Roman, 3rd or 4th century; the **animal bases** are probably late Medieval.

ALONG THE CLOISTER WALL: four stone **windows** (probably Southern Italian, 14th–15th c.). The stone **doorway** (Central Italian, 16th c.) is inscribed: *AVE MARIA GRATIA PLENA* (Hail Mary, full of grace) and dated *M • D • XII [•] IVLVS • DXX*. The latter refers to Julius II, pope from 1503 to 1513. The two painted copper **lanterns** here and flanking the tabernacle by Bartolomeo Giolfino (see p. 49) are Italian, 18th century.

BETWEEN THE TWO WINDOWS TO THE LEFT OF THE DOORWAY: architectural and sculptural **fragments of an *ambo*** (pulpit and reading desk) from the church of S. Lucia in Gaeta (South Italian, first quarter of the 13th c.), purchased from Ditta Pio Marinangeli, Rome, 1897. Of these, four marble **reliefs** framed in a colored **mosaic** of Cosmati work represent the winged lion of *Saint Mark* (upper left), the winged bull of *Saint Luke* (upper right), and (below) a *stag* and a *basilisk*.

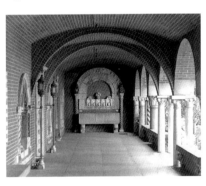

The East Cloister, looking South toward the fountain.

AT THE NORTH END, ABOVE THE ARCHED DOORWAY TO THE RIGHT: large stone **escutcheon** (Spanish, 16th c.). The arms are those that the Holy Roman Emperor Charles V (1500–1558) adopted after his marriage to Isabella of Portugal. Said to have originally hung in the cathedral at Grenada, it was acquired in 1909 through the assistance of Joseph Lindon Smith.

➤ TO THE LEFT OF THE ARCHWAY:

North Cloister

Carved limestone **retable** from Lorraine, ca. 1425, representing six scenes of the Passion, with the Crucifixion in the center. The kneeling donors of this work are at each end, with their patron saints, John the Baptist and Catherine of Alexandria. BELOW: three limestone **capitals** or **imposts** (French Romanesque, 12th c.), depicting, from left to right, several scenes of the Passion, a calendrical illustration for March, and perhaps Daniel in the lions' den. The imposts and the retable were purchased from the Émile Peyre collection, Paris, in 1897 and 1899, respectively. ABOVE: silver **sanctuary lamp** (Spanish, 17th c.).

LEFT, ON AN INVERTED CAPITAL: marble **holy water basin** (North Italian, possibly Milan, ca. 1100). ABOVE: stone **gargoyle** (French, 13th c.).

Scenes from the Passion on a limestone retable
from Lorraine, ca. 1425.

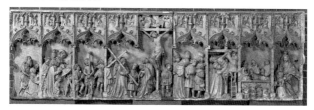

On the Court side, on a column: Istrian stone **figure** of *Saint Christopher* (North Italian, 16th c.). To the right on a capital on the bench: **head of a divinity** (Apollo?) (Graeco-Roman, in the manner of Praxiteles).

In the center, flanking the steps: two marble columns on **stylobate lions**. On the left, a kneeling *atlante* shares the burden of support (North Italian, 12th or early 13th c.). On the right, a man, imprisoned in the claws of a lion, plunges a knife into its flank (Tuscan, 13th c.).

The pair of figured **capitals** are Roman, 3rd century. From a rare design of complex foliage emerge centaurs with amphorae. Dionysiac figures appear on each side of each capital. The wrought-iron **gate** opposite them is Italian, 17th century.

Through the gate is the Exit, Coat Room (left), and Blue Room (right).

At the end of the hallway, flanking the exit: Left: **Saint George**, polychromed wood (Bavarian or Tyrolian, ca. 1500–10); right: **Saint Florian**, polychromed wood (South Bavarian or Austrian, ca. 1520–25). Both purchased from Theodor Einstein & Co., Munich, 1897.

The wooden **benches** here and in the North Cloister are Italian, 16th century, and were a commonly used wall decoration in Italian palaces during the Renaissance. The **exit doors** are French Gothic, 12th or 13th century, purchased from the Émile Peyre collection, Paris, 1897.

➤ Passing through the wooden door between the benches:

Blue Room

The three **fabrics** covering the wall (satin and moiré stripe; feather and floral design; and cornucopia design) are reproductions of late 18th-century fabrics installed by Isabella Gardner.

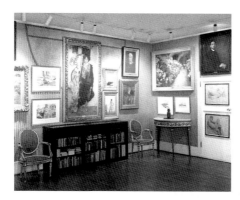

The Blue Room, looking toward Antonio Mancini's *Standard Bearer of the Harvest Festival* in the center of the South Wall, and Dennis Miller Bunker's *Chrysanthemums* in the corner.

ABOVE THE DOOR: *John Briggs Potter*, ca. 1903, by Denman Waldo **Ross** (American, 1853–1935), gift of the artist, 1905. The sitter was Keeper of Paintings at the Museum of Fine Arts from 1902 to 1927.

TO THE RIGHT: ABOVE: *Mrs. Grover Cleveland*, 1899, by Anders Leonard **Zorn** (Swedish, 1860–1920), a birthday gift from the artist in 1899. BELOW: *The Little Groom*, by Antonio **Mancini** (Italian, 1852–1930), purchased from Nicola Pierangeli, Rome, 1895. BENEATH THE PAINTINGS: wooden **chair** (Italian, probably 18th c.), with a rush seat, from a set of six in the room; and a **refectory table** (Italian, 17th c.).

ON THE TABLE, LEFT TO RIGHT: *A Tent in the Rockies*, 1916, watercolor on paper, by John Singer **Sargent** (American, 1856–1925), purchased from the artist through Doll & Richards, Boston, 1916; and *A New York Blizzard*, ca. 1890s, pastel on paper, by Childe **Hassam** (American, 1859–1935). The bronze **vases** are Japanese, 19th century, and Chinese, early 19th century.

ABOVE THE TABLE, TOP TO BOTTOM: *A Theatre, Mukden*, ca. 1905, by Joseph Lindon **Smith** (American, 1863–1950), purchased from the artist, probably 1908; *A View Across a River*, ca. 1855, by Gustave **Courbet** (French, 1819–1877); *Among the Rocks*, after 1906, oil on board, by Howard Gardiner **Cushing** (American, 1869–1916).

AT THE RIGHT, TOP TO BOTTOM: *Ponte della Canonica*, 1912, by Caleb Arnold **Slade** (American, 1882–1934), purchased from the artist, 1915; *The Shore, Étaples*, ca. 1913, oil on cardboard, by **Slade**, purchased from the artist, 1915; *A Snow-Capped Mountain*, watercolor on paper, by Rodolfo Amadeo **Lanciani** (Italian, 1846–1929).

ABOVE THE DOOR TO THE RIGHT: *The Gondola*, 1884, by Ralph Wormeley **Curtis** (American, 1854–1922), purchased from the artist, 1884.

TO THE LEFT OF THE DOOR, TOP TO BOTTOM: *The Recording Angel*, 1890, watercolor on paper, by John **La Farge** (American, 1835–1910), purchased from Doll & Richards, Boston, 1893; and *The Spirit of the Waterlily*, 1861/62, watercolor on paper, by **La Farge**, a study for a stained-glass window, purchased from Ortgies & Co., New York, 1884. ON THE DOOR ITSELF: *A Head by Desiderio*, 1894, watercolor on paper, by Joseph Lindon **Smith**, purchased from the artist, probably 1894. A study of the tomb of Carlo Marsuppini, S. Croce, Florence, by Desiderio da Settignano.

AROUND THE CORNER, ON THE SHORT WALL:

AT THE LEFT, TOP TO BOTTOM: three watercolors by **Sargent**: *Santa Maria della Salute, Venice*, 1903/04, purchased from Doll & Richards, Boston, 1916; *Bus Horses in Jerusalem*, 1905, probably acquired from the artist, late 1906; *Incensing the Veil*, ca. 1880, a study for *Fumée d'Ambre Gris* (Clark Art Institute, Williamstown), purchased from Farr, Philadelphia, 1919.

AT THE RIGHT, TOP TO BOTTOM: *Violet Sargent*, 1890, by **Sargent**, acquired from Lucia Fairchild Fuller, through Eleanor Platt, the widow of the painter Dennis Miller Bunker, 1895; *Headland*, pastel on paper, by Karl Frederick **Nordström** (Swedish, 1855–1923), acquired on the recommendation of Anders Zorn; *The Marriage at Cana*, watercolor on paper, by George Hawley **Hallowell** (American, 1871–1926), after Tintoretto, probably

acquired from the artist. BELOW: two **side chairs** (Italian, 18th c.) with caned seats and backs; part of a set with the armchairs in this room (see p. 35) and the settee in the Macknight Room (see p. 44).

BETWEEN THE CHAIRS, IN THE *PRICHARD CASE*: **letters** from friends of Gardner, including Matthew Stewart Prichard, Thomas Whittemore, Abram Piatt Andrew, and Fanny Alexander.

TO THE RIGHT, NEXT TO THE WINDOW: marble *torso*, by Dennis Miller **Bunker** (American, 1861–1890), said to be a gift, painted when the artist was very young. BELOW, IN THE *OKAKURA CASE*: materials related to Okakura Kakuzo, including a **photograph**, painting **brush**, **poetry**, **letters**, and **manuscripts**; photographs of others, including Ralph Waldo Emerson, Walt Whitman, Sarah Orne Jewett; a first edition of **The Scarlet Letter** with a lock of Nathaniel Hawthorne's hair; and a portrait drawing of *George Santayana*, 1897, by Andreas **Andersen** (Norwegian-American, 1869–1902).

AT THE RIGHT, ON THE PROJECTING WALL: *The Omnibus*, 1892, by **Zorn**, purchased from the artist at the World's Columbian Exposition, Chicago, 1893. BELOW, IN THE *BERENSON CASE*: materials related to Berenson, including a **photograph** and **correspondence**, along with letters from Chandler Post, T. S. Eliot, Edward Forbes, Julia Ward Howe, Ida Agassiz, and Henry Lee Higginson.

The Omnibus,
by Anders
Zorn, 1892.

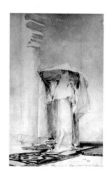

*Incensing the
Veil*, by John
Singer Sargent,
ca. 1880.

On the end of the wall facing South: *The Peacocks of Immortality*, painted plaster medallion, by **Sargent**, a study for his relief decoration in the Boston Public Library. With another in this room, and seven in the Macknight Room (see p. 41), they were a gift of the artist. *Head of Mrs. Gardner*, a pencil and red chalk study for *Mrs. Gardner in Venice*, 1894, by **Zorn** (see Short Gallery, p. 66). The frame is Venetian, 18th century. Above is a wrought-iron **lantern** in the form of a boat (Japanese, 19th c.).

On the other side of the projecting wall: *Nasturtiums*, gouache on paper, by Jan **Voerman** (Dutch, 1857–1931), purchased from Frans Buffa & Zonen, Amsterdam, 1894, through Ralph Curtis. Below: *Madame Gautreau Drinking a Toast*, 1882–83, by **Sargent**, acquired at the Pozzi Sale, Paris, 1919, through Louis Kronberg. Done while painting her portrait, *Madame X* (Metropolitan Museum of Art, New York). Underneath are two **armchairs** (Italian, possibly Lombard, late 18th c.).

In the corner to the left, top to bottom: *George Proctor*, by **Andersen**, probably acquired from the artist in 1898; *A Samoan Dance*, 1890, by **La Farge**, purchased from the artist, through his son Bancel La Farge, New York, 1892; *The Oaks of Monterey*, 1904, by Francis **McComas** (Australian-American, 1874–1938), gift of the artist, 1904. Hanging in the window: wooden **gong** in the form of a fish (Japanese, middle of the 18th c.); to the right of the gong: brass and paper **lantern** in the form of a gourd with a mantis (Japanese, ca. 1850); beneath the window: chair-back **settee** (English, Sheraton period, last decade of the 18th c.).

In the corner to the right: *The Shower of Gold*, 1908, by **Cushing**, purchased from the artist or the sitter (his wife, Ethel Cochrane) before 1916. Below: *Henry James*, 1910, by William **James** (American, 1882–1961), the sitter's nephew, gift of the artist, 1910.

EAST WALL:

Noonday, by Jean Baptiste Camille **Corot** (French, 1796–1875), purchased from Doll & Richards, Boston, 1880. BELOW: *The Bird House, Villa Borghese, Rome,* 1922, by Martin **Mower** (American, 1870–1960), a birthday gift from the artist, April 14, 1922.

Yoho Falls, 1916, by **Sargent**, acquired from the artist through Doll & Richards, Boston, 1916. BELOW: **writing desk** (Italian, 19th c.) with inlaid marquetry top (South German, 17th c.). ON THE DESK: *The Nativity*, watercolor on paper, by **Hallowell**; English silver **teapot tray**, 1792/93; faience **inkstand** (French, 18th c.) with the arms of Alexandre, count of Toulouse (1678–1737); brass **tobacco box** (Dutch, 18th c.) inscribed with a perpetual calendar; *Drake*, bronze, by Jane **Poupelet** (French, 1878–1932), purchased at an exhibition at the Museum of Fine Arts, 1912; and a painted Russian **tray** depicting the *Adoration of the Magi.*

ON THE WALL TO THE RIGHT: *Astarte*, 1893/94, by **Sargent**, a study for the murals at the Boston Public Library, purchased from Robert Dunthorne, through Richard Davis and Sally Fairchild, 1896. The study had been a gift to Frederic Leighton when the artist entered the Royal Academy.

ABOVE THE MIRRORED DOORS: carved and gilt **mirror top** (Italian, 19th c.).

TO THE RIGHT, IN A CASE: porcelain **vase** (Chinese, K'ang-hsi period, 1662–1722). The **case** may be Italian or German (early 19th c.); the tiny piece of linen under the glass at top might be a religious relic.

SOUTH WALL:

Blue Nets—Concarneau, I, by Boris **Anisfeld** (Russian-American, 1879–1973), purchased from an exhibition at The Boston Art Club, 1918.

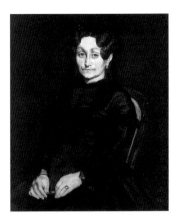

Edouard Manet's portrait of his mother, *Madame Auguste Manet*.

Madame Auguste Manet, 1869/70, by Edouard **Manet** (French, 1832–1883), purchased from Wallis & Son, London, 1910, through Berenson. BELOW IT: *Chez Tortoni*, ca. 1878–80, by **Manet**, purchased from the Dikran Khan Kelekian Sale, Paris, 1922, through Louis Kronberg. ***THIS PAINTING WAS STOLEN FROM THE MUSEUM ON MARCH 18, 1990.*** ON THE TABLE BELOW: stone **mortar** (possibly Florentine, 16th c.); two small wooden **lions**, probably finials (North Italian, possibly Bolognese, 15th c.); and a wooden **box** (North Italian, 15th c., with some 17th-c. decorations).

IN THE CORNER, TOP TO BOTTOM: *The Surge of the Sea*, ca. 1900, by **Andersen**, purchased from the artist, 1900; **case** (Italian, 18th c.) containing a **crosier** (Italian, possibly 15th c.); both resting on a lacquer **chest** (Chinese, 19th c.). AT THE RIGHT: **armchair** (Italian, probably Lombard, 18th c.) in the Louis XVI style.

ON THE PROJECTING WALL, TOP TO BOTTOM: *The Scapegoat*, plaster medallion, by **Sargent**; *Sheep in the Shelter of the Oaks*, by Charles Émile **Jacque** (French, 1813–1894), purchased from Doll & Richards, Boston, 1873; *Ponte della Canonica*, 1903/04, watercolor on paper, by **Sargent**, purchased from Anderson Galleries, New York, 1920, through Louis Kronberg.

ON THE END OF THE PROJECTING WALL, FACING NORTH: *Bust of Akhenaton*, 1908, by Joseph Lindon **Smith**, after the sculpture in the Musée du Louvre, Paris, acquired from the artist, probably in 1908; *A She-Goat*, by Rosa **Bonheur** (French, 1822–1899), purchased in 1900, presumably from the artist's estate; *The Beach*, ca. 1908, by **Ross**, gift of the artist, 1910.

ON THE OTHER SIDE OF THE PROJECTING WALL: *Self-Portrait*, ca. 1910, by Ignaz Marcel **Gaugengigl** (German-American, 1855–1932), purchased from the artist in 1920. Painted for the Tavern Club, Boston, it was returned with the painter's resignation during World War I. *The Crusader*, ca. 1840, oil and bitumen on cardboard, by Ferdinand Victor Eugène **Delacroix** (French, 1798–1863), purchased from S. M. Vose, Boston, 1882. The **console table** (with the one opposite it) is Venetian, 18th century. On this one is a **cinerary urn** (Roman, Julio-Claudian or early Flavian period).

CONTINUING ALONG THE SOUTH WALL: *Abram Piatt Andrew, Jr.*, 1911, by **Zorn**, commissioned from the artist in 1911, when he was visiting the congressman in Washington, D.C. BELOW IT: *The Brook at Medfield*, 1889, by **Bunker**, purchased from the artist, 1889. AT THE RIGHT, TOP AND BOTTOM: two watercolors by **Sargent**: *The Terrace at La Granja*, 1903/04, and *San Giuseppe di Castello*, 1904. Both acquired with *Ponte della Canonica* (p. 34).

INSIDE THE *CRAWFORD CASE*: **photographs** and **correspondence** with Francis Marion Crawford, William James, Thomas Russell Sullivan, Henry James, James Russell Lowell, Charles Eliot Norton, William Dean Howells, and Oliver Wendell Holmes, Jr., among others. Also collected **manuscripts** of Henry Wadsworth Longfellow, William Cullen Bryant, and others. The plaster **cast** is of William Greenleaf Whittier's hand. FLANKING THE CASE: two **armchairs** (Italian, late 18th-c. adaptation of Louis XVI style) with caned seats and backs; they are part of a set with the side chairs in this room (p. 31) and the settee in the Macknight Room (see p. 44).

ABOVE THE CASE: *Standard Bearer of the Harvest Festival*, by **Mancini**, purchased from the artist, Rome, 1895, through Ralph Curtis. On the wall behind the painting is a **cope** (Italian or French, 1700–25). TO THE RIGHT, ABOVE AND BELOW: *Snow*, 1859/60, by **La Farge**, purchased from Leonard & Co., Boston, 1878; and *At the Window*, before 1918, by Louis **Kronberg** (American, 1872–1965), probably acquired from the artist. CONTINUING: *The Bandaged Head*, 1919, by **Ross**, gift of the artist; and *A Lady with a Rose*, pastel on paper, by Albert **Besnard** (French, 1849–1934), acquired from the artist, Paris, 1892.

ON THE WEST WALL, TO THE LEFT OF THE DOOR: *Chrysanthemums*, 1888, by **Bunker**, gift of the artist in 1889. Painted in the greenhouses at Green Hill, Gardner's estate in Brookline, Massachusetts. BELOW: two watercolors by Francis Edward **James** (English, 1849–1920): *Bridge of Boats to Campo Santo, Venice, All Souls' Day*, 1892; and *Santa Maria della Salute from the Giudecca*, both probably gifts from the artist. On the table is a bronze **vase** (Korean, 18th c.).

The door is modern, with 16th-century French **carved panels** set into it. On the back are two academy drawings by **Bunker**, *Torso* (top) and *Day* (from the Medici Tomb), done in 1883/84 when Bunker was a student at the École des Beaux-Arts, Paris. The artist inscribed *Torso* with a quote from his teacher Jean-Leon Gérôme, which translates: "These torsos are the foundation of instruction. One must be suckled on these things in youth." Purchased at the artist's memorial exhibition, St. Botolph Club, Boston, 1891.

Court

Protected by its roof of glass four stories above, the Court is always in bloom with plants and flowers supplied by the Museum's greenhouses. There are displays of freesia, jasmine, and azaleas in the spring; lilies and cineraria at Easter; chrysanthemums in autumn; and poinsettias at the end of the year. Many varieties of orchids are shown throughout the year.

The stone **arches, columns, capitals,** and **inset reliefs** are partly old, with examples from the Roman, Byzantine, Romanesque, Gothic, and Renaissance periods, and partly modern. In the spandrels of the Cloister arches, and in the panels above the arched windows of the upper floors, are thirty-eight circular stone **medallions**, carved in relief with animals

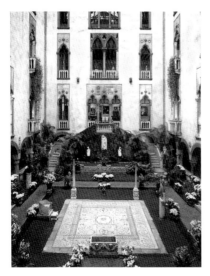

The Court.

and birds. These are Venetian and were employed in the embellishment of the facades of buildings from the 12th century onward. The **window frames** and **balconies** are from Venetian buildings from the 14th to the 16th century, with the **balustrades** coming from the celebrated Cà d'Oro in Venice. The pink brushwork of the stuccoed walls was, in places, applied by Gardner herself. The final result is as if a nearly symmetrical Venetian palazzo were turned inside out, but no one structure was dismantled to create it.

AT THE CENTER OF THE COURT: **mosaic** (Roman, 2nd c.), purchased from Ditta Pio Marinangeli, Rome, 1897. The head of the Gorgon, Medusa, is in the center. JUST BEYOND THE MOSAIC, TO THE SOUTH: **Horus Hawk**, granite (Egyptian, probably Ptolemaic, 331–300 B.C.), purchased from Galleria Sangiorgi, Rome, 1895. In the Egyptian pantheon, the hawk was the sun god Horus, personified on earth by the ruling king. To the left and right of Horus at the corners of the mosaic are decorated **shafts** (Roman, 1st or 2nd c.) placed upon Roman **cinerary urns**; purchased from Stefano Bardini, Florence, 1899.

ON THE SOUTH WALL, SET INTO THE FRONT OF THE STAIRCASE: the **fountain** (Venetian, 17th c.)—with its friezelike rim made up of panels carved with sea animals, monsters, and mythical beings—has above it a marble **relief** of a *maenad or hora* (Graeco-Roman, 1st or 2nd c.). One of a series of eight dancing maidens, which together formed a small, circular tomb or base for a Dionysiac tripod. The two Istrian stone **dolphins** are Venetian, 17th century or later. In front of the fountain on the ground is a terra-cotta **amphora** (storage jar) (Sicilian or Roman) for wine or oil.

ON THE SOUTH WALL, SET INTO THE SECOND STORY: two stone **reliefs** (Venetian, 12th c.): *Peacocks* (center left) and *Winged Ox* (center right), with an open book inscribed: *S. Lucas*; and (far left and right), two **lion antefixes** (Tuscan, 12th c.).

TO THE WEST OF THE MOSAIC (RIGHT SIDE), ON A PEDESTAL FACING EAST: an **amazon or Artemis the huntress**, marble (Graeco-

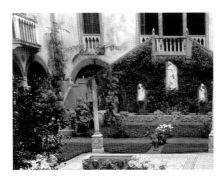

The Court, looking South past the Graeco-Roman *Peplophorus.*

Roman, a copy of a Greek original of the late 5th or early 4th c. B.C.), purchased through Richard Norton, Rome, 1901.

IN THE NORTHWEST CORNER OF THE COURT (TO THE IMMEDIATE RIGHT): headless marble **figure** of a woman in Doric dress (*Peplophorus*) (Graeco-Roman, a copy of a Greek bronze of ca. 455–450 B.C.), acquired by Gardner through Richard Norton in 1901, the year it was unearthed in Rome. Loaned to the American Academy in Rome until an export license could finally be obtained for it thirty-five years later, it would complete the installation of Gardner's collection at Fenway Court— twelve years after her death.

CONTINUING COUNTERCLOCKWISE:

SOUTH OF THE MOSAIC: small limestone **garland sarcophagus** (Greek Imperial, ca. 250), with a portrait bust of a child. Purchased from the Jandolo Brothers, Rome, 1897.

IN THE NORTHEAST CORNER (TO THE IMMEDIATE LEFT): marble **goddess** (Persephone?) **or woman** (Greek, 1st c. B.C. or A.D., after a work of ca. 350 B.C.), purchased through Richard Norton, Rome, 1901.

TO THE IMMEDIATE EAST OF THE MOSAIC: marble **throne** (Roman, 1st c.), with a bearded winged figure in Near Eastern garb, purchased through Richard Norton, Rome, 1901.

INSIDE THE ARCHED WINDOW OVER THE STAIRS (IN THE SOUTHEAST CORNER): the crouched **figure** is *Odysseus Creeping Forward during the Theft of the Palladium* (Roman, ca. 25 B.C.–125 A.D.). Made to go in the corner of a pediment, he is a rare depiction of Ovid's tale of the theft of the talisman protecting Troy, allowing the city to fall to the Greeks. Found at Villa Spithover in the Gardens of Sallust in 1885, it was purchased through Richard Norton, Rome, 1898.

SET INTO THE NICHES OF THE EAST WALL OF THE COURT, FIRST-STORY SPANDRELS: two stone **saints** (Venetian, 15th c.), representing *Saint John the Baptist* and a *Bishop Saint*.

➤ THROUGH THE DOOR:

Macknight Room

This was one of Gardner's sitting rooms, after its renovation in 1916. Prior to that time, it had been a guest room, where John Singer Sargent sometimes slept, along with others such as Matthew Stewart Prichard, who lived here from 1903 to 1906, during his tenure as assistant director of the Museum of Fine Arts, Boston. Although Isabella Gardner periodically opened it up to the public and bequeathed it as part of her Museum, the room constitutes the only remaining private chamber among the other galleries at Fenway Court.

ON THE DOOR IN THE CLOISTER: a bronze dolphin **knocker**, an iron **grill**, and a large iron **lock** (Italian, possibly 15th c.). The lock was a gift of Henry Davis Sleeper.

OVER THE DOOR INSIDE THE ROOM: *Almond Trees, Valserres*, 1894/95, by Dodge **Macknight** (American, 1860–1950), purchased from the artist, 1907. A close friend of Gardner's, this room was named for him and contains eleven of his works.

CONTINUING ALONG THE SOUTH WALL, TO THE RIGHT: **commode** (Venetian, middle of the 18th c., Louis XVI style) with souvenirs

The Southeast corner of the Macknight Room, with John Singer Sargent's 1922 portrait of *Mrs. Gardner in White* on the bookcase to the left.

and other personal items on it. The glass **bottles** contain sand collected in Egypt in 1875, one from near the Sphinx, the other at the Great Pyramid at Giza. A gift of the artist in 1923, the glazed "Avalon" **tile** was made by Henry Chapman **Mercer** (American, 1856–1930), who did the tiles on the second and third floor (see pp. 51 and 88). Gifts from other artists include the blue-green glazed rose jar by Anita **Linzee** (d. 1931); and the green pottery dog and hexagonal box by Frances **Curtis** (dates unknown). The crystal **box** is marked with a *Y*, adopted by Isabella Gardner as a personal logo; taken from the Spanish spelling of her name and found on many objects in the building, it is also present in large scale on the exterior facade. The enameled glass **goblet** is modern, a souvenir of the rebuilding of the Campanile, Venice, a gift of Mary Curtis, 1912. The green glass **bowl** (Czech, 20th c.) was a gift of Mrs. Bryce Allan, 1921. The photograph is of a drawing of John Singer Sargent, by Alexander **James**.

ABOVE THE COMMODE: plaster study by John Singer **Sargent** (American, 1856–1925) for a relief at the Boston Public Library. There are seven such studies in this room, as well as two others in the Blue Room, p. 32; all were gifts of the artist. This one depicts *The Crown and Palms of Martyrdom*. BELOW: *A Lane Through an Orange Grove, Orihuela*, 1904, watercolor on paper,

by **Macknight**, gift of the artist, probably 1905; *In a Turkish Garden*, 1910, watercolor on paper, by William **Ranken** (Scottish, 1881–1941), purchased from Doll & Richards, Boston, 1917. LEFT: *Danseuse à la Barre*, charcoal, crayon, and watercolor on paper, by Hilaire-Germain-Edgar **Degas** (French, 1834–1917), purchased from Durand-Ruel, New York, 1920, through Louis Kronberg. BELOW IT: *The Bridge*, sepia and pencil on paper, by an **unknown artist** (Dutch, 17th c.), bequest of William Payne Blake, 1922, as a work by Fragonard.

TO THE RIGHT, ABOVE AND BELOW: *Parrot*, ca. 1915, watercolor on paper, by Edward Newell **Marshall** (American, dates unknown), purchased from Doll & Richards, Boston, 1916, on the recommendation of Sargent; *Souvenir of Faust*, 1915, watercolor on paper, by Louis **Kronberg** (American, 1872–1965), probably gift of the artist.

ABOVE THE DOOR: *The Pool, Shelburne*, 1914, watercolor on paper, by **Macknight**, purchased from Doll & Richards, Boston, 1914.

CONTINUING: *Villa Sylvia, St. Jean-sur-mer*, 1923, by Sylvia **Curtis** (American, 1899–1967), gift of the artist, 1923. The daughter of the artist Ralph Wormeley Curtis, Sylvia Curtis was Isabella Gardner's goddaughter. BELOW IT, LEFT AND RIGHT: *Nasturtiums at Fenway Court*, 1919, by Arthur **Pope** (American, 1880–1974), gift of the artist, 1919. A professor at Harvard, Pope was also one of the Museum's first trustees; and *The Long Gallery, Fenway Court*, 1922/23, by Martin **Mower** (American, 1870–1960), a birthday gift from the artist, 1923. Although painted much later, it depicts the Long Gallery as it appeared before 1914. In front is a so-called **tip-top table** (Italian, 18th c.).

TO THE RIGHT, TOP TO BOTTOM: *A Little Girl of Douarnenez*, 1889, pastel on paper, by **Macknight**, purchased from Doll & Richards, Boston, 1890. It was given to Theodore Dwight and returned as his bequest in 1917. *The Road to Cordoba, Mexico*, 1907, watercolor on paper, by **Macknight**, purchased from the artist, probably in 1908. *Beaulieu*, watercolor on paper, by

Hercules Brabazon **Brabazon** (English, 1821–1906), purchased from the musician William Shakespeare, through Sargent, 1920. The **corner desk** is English, late 17th century, William and Mary style. Near it is a Sheraton–style **chair** (English or Italian, first half of the 19th c.); another is on the North side of the room.

IN THE WINDOW: **aeolian harp**, made in Boston, 1906. When strung, the harp is played by the wind. ABOVE THE WINDOW: another plaster study by **Sargent**, *The Seven-Branched Candlestick* (in a medallion). The **leather strips** hanging on either side of the windows in this room are probably Italian, 16th century.

ON THE PROJECTING WALL, TOP TO BOTTOM: *Venetian Scene*, 1886, by Paul **Tilton** (American, 1859–1917), purchased from the artist, Venice, probably 1895; *Venetian Lagoon*, by Pietro **Fragiacomo** (Italian, 1856–1922), purchased from the artist, Venice, 1884; *The Dead Lion*, watercolor on paper, by Raphaele **Mainella** (Italian, 1858–1942).

ON THE PROJECTING WALL, FACING INTO THE ROOM: **console table** (Venetian, middle of the 18th c.), supporting the *Diana*, 1920, bronze, by Paul **Manship** (American, 1885–1966), purchased from the artist, through Scott & Fowles, New York, 1921. On

Paul Manship's bronze *Diana*.

the wall behind is a **mirror** (possibly Venetian, second half of the 18th c., Louis XVI style). Flanking it are blue glass **candlesticks** (Venetian, modern) on brackets. To the right is a **clock** (Japanese, ca. 1800). Below it is a wrought-iron **container** for wooden matches. On the floor to the left of the table is a **basket** (Japanese, middle of the 19th c.).

ON THE FAR SIDE OF THE PROJECTING WALL, TOP TO BOTTOM: *The Bay, Belle-Îsle*, 1890, watercolor on paper, by **Macknight**, purchased from Doll & Richards, Boston, 1891; *The Lagoon, Venice*, ca. 1884, pastel on paper, by John Henry **Twachtman** (American, 1853–1902); and *Santa Maria dei Gesuati, Venice*, 1903/04, watercolor on paper, by **Sargent**, purchased from Daniel Farr, Philadelphia, 1920. Hanging from a bracket is a **net float**; hanging from the iron candle bracket is a modern porcelain **bird**, purchased in New Hampshire at a war charity benefit, 1916/17. The **settee** is from the set of chairs in the Blue Room, see p. 31. Above the window is a plaster study by **Sargent**, *The Ark of the Covenant*.

TO THE RIGHT OF THE WINDOW, TOP TO BOTTOM: *Peonies*, by Denman Waldo **Ross** (American, 1853–1935), gift of the artist; and *A View of Popocatepetl from Cuantla*, 1923, watercolor on paper, by **Ross**, gift of the artist, 1923. BELOW: walnut **cupboard**, supporting a red lacquer **box** (Japanese, ca. 1870), and miniature carved **galleon** containing wax and glass **fruit**, a gift of Paul Chalfin.

ON THE DIAGONAL WALL: *The River at Concord*, 1915, by Elizabeth Wentworth **Roberts** (American, 1871–1927), purchased from Doll & Richards, Boston, 1915; BELOW: *The Meet*, probably 1914, pastel on canvas, by **Mower**, gift of the artist, 1914. IN FRONT OF THE WALL: **stand** (English, 19th c.) supporting a red and black lacquer **box** (Japanese, early 19th c.).

Above the window are two more plaster studies by **Sargent**: *Tabernacle of the Eucharist with the Wafer* and *Head of the Burnt Offering*. Below the window is a large wheeled **armchair** (North Italian, Este, first half of the 19th c.) with an adjustable back. Gardner called it the "Goldini Chair." In front of it is a small **table** (Venetian, modern) with a removable tray top, a gift of Sarah Choate Sears, 1921. ON THE TABLE: three silver Turkish *zarfs* (cups on pedestals for coffee); a circular silver **box** (probably Indian, 19th c.); a **damascene workbox** (Korean, early 19th c.); and a brass **vessel** (Chinese, middle of the 19th c.).

ABOVE THE DESK BETWEEN THE WINDOWS, TOP TO BOTTOM: *Moonrise*, ca. 1886, pastel on paper, by Dennis Miller **Bunker** (American, 1861–1890), possibly the only extant pastel by the artist, purchased at his memorial exhibition, St. Botolph Club, Boston, 1891; *Peonies*, by Wilton **Lockwood** (American, 1861–1914), purchased from Brooks Reed, Boston, 1914; *A Japanese Teahouse,* watercolor on paper, by Ralph Wormeley **Curtis** (American, 1854–1922), gift of the artist; and to the right of it, *Matthew Stewart Prichard*, 1905, pen and watercolor on paper, by John Briggs **Potter** (American, 1864–1949), gift of the artist, executed at Fenway Court.

BELOW: **writing desk** with two side **cupboards** (possibly Venetian, 19th c.); at the desk is a **chair** from the set in the Short Gallery (see p. 67). ON THE DESK: a number of personal effects and other items left there by Isabella Gardner. Among them are: silver **hand mirror** made from a knitting needle case (Dutch, 1852–59); two silver **candlesticks** (Venetian, 18th c.); creamware **inkstand** (English or French, 18th c.) with the bust of a man; in it is a small silver frame containing an early **photograph** of Isabella Gardner; two Japanese **cigarette boxes** (one a gift from William John Gunn, the other from Abram Piatt Andrew); small aubergine pottery jar, made by Mona **Freer** (dates unknown), a gift of Mrs. R. M. Appleton, 1923;

Isabella Gardner's desk in the Macknight Room.

square glass **bottle** (probably Dutch, 18th c.) with a pewter top; glazed pottery **table lamp** (made for kerosene, converted to gas, then electricity), with a small watercolor leaning against it: *Notre Dame de Rheims: La Chapelle Obsidiale*, 1913, by Adrien **Sénéchal** (French, 1896–date unknown); behind the lamp is a **lacquer box** (Japanese, early 19th c.) in four sections; standing on it is a **box** (possibly Scandinavian) with a sliding front; the **portfolio** is Venetian, the leather-covered **magnifying glass** is German, the ivory one Japanese, the **letter opener** is ivory. On the **tray** is a **sword guard** (Japanese, 18th c.); silver filigree **box** (possibly East Indian); alabaster **figurine** in the shape of a turtle with an ankh on its back; a folding **knife** with a black bone handle; an ivory **box** (possibly Indian); a hollow **bronze block** with a figure of a snake on it; and **scissors**.

TO THE RIGHT: **inlaid stand** (Italian, 18th c.) with two drawers. ON IT: two sets of **candle snuffers** and **trays**, and a Sheffield plate **candlestick**. In front of the window is the second Sheraton–style **chair** with a small oak **basket** hanging from its back. Above the window are another pair of plaster studies by **Sargent**: *The Seven-Branched Candlestick* (in a cartouche) and *The Instruments of Music*.

To the right on the diagonal wall, top to bottom: *A Sunny Corner in Venice*, gouache and pencil on cardboard, by Francis Hopkinson **Smith** (American, 1838–1915), purchased from Doll & Richards, Boston, 1892; *Moonrise on a Canal*, pastel on paper, by Sarah Wyman **Whitman** (American, 1842–1904), probably purchased from Doll & Richards, Boston, 1878 [Whitman was also the designer of the Museum's crest, with the rising phoenix, visible on the front of the building]; and *La Maladetta*, 1922, pastel on paper (in the shape of a fan), by **Kronberg**, probably a gift of the artist. In front of the wall, a semicircular **table** (English or Italian, Louis XVI style) supports a porcelain **flowerpot** (Chinese, Yung-chêng period, 1723–1735).

To the left of the door, top to bottom: *Dolphins*, before 1917, watercolor on paper, by Charles Herbert **Woodbury** (American, 1864–1940), purchased from the artist, 1921; *A Woman in a Lane*, 1907/08, watercolor on paper, by **Macknight**, gift of the artist; and two watercolors by **Kronberg**: *Back to Back*, 1914 (left), and the *Grand Canal, Venice*, 1914, both probably gifts of the artist in that year. In front of them are a **tip-top table** with mother-of-pearl inlay (Japanese, middle of the 19th c.) and an **armchair** (English, Chippendale, middle of the 19th c.). Above the door: *Towering Castles, Grand Canyon*, probably 1914, watercolor on paper, by **Macknight**, purchased from Doll & Richards, Boston, 1915.

To the right of the door, top to bottom: *The Basin, Shelburne,* 1910, watercolor on paper, by **Macknight**, probably a gift of the artist, 1914; *Gladioli*, 1915, pastel on paper, by Sarah Choate **Sears** (American, 1858–1935), purchased from the artist, 1915; *A Girl of Nabeul*, 1921, oil on paper, by Caleb Arnold **Slade** (American, 1882–1934), purchased from the artist, 1921. Below: another **tip-top table**, and **bookcases** that continue the length of the wall. Mounted on the side of the first bookcase is a **woodblock** for printing (Italian, 16th or 17th c.) depicting *Saint Anthony*; on top of it is a black **lacquer box** (Japanese, early 19th c.); a second one is on the other short bookcase.

CONTINUING ALONG THE BOOKCASES: *Mrs. Gardner in White*, 1922, watercolor on paper, by **Sargent**, painted in this room, gift of the artist in that same year; bronze bust of *Maria de Acosta Sargent*, 1915, by Anna Coleman **Ladd** (American, 1878–1939), purchased from the artist, 1915, the year Gardner held a solo exhibition of her work here at Fenway Court; behind the bust is a Louis XVI **mirror** (Italian, 17th c.); above it is *Rio di San Salvatore, Venice*, 1903/04, watercolor on paper, by **Sargent**, purchased from Frank Bayley, Copley Gallery, Boston, 1923; below the bust is *A Gateway in Tunis*, oil on paper, by **Slade**, gift of the artist, 1921; CONTINUING TO THE RIGHT: *Thomas Whittemore*, 1922, charcoal on paper, by **Sargent**, gift of the sitter; *A Road in Winter, Cape Cod*, 1901–04, watercolor on paper, by **Macknight**, depicting the artist's son John as a boy, gift of Denman Ross; and *Coppelia*, 1911, crayon on gray paper, by **Kronberg**, gift of the artist. ON TOP OF THE LAST BOOKCASE: cut-glass **decanter** in the shape of a thistle (probably Scottish, 19th c.). Also mounted on the front of the cases are a pair of silver **cupids with bénitiers** (holy-water fonts) (Italian, 19th c.) acquired from Gebelein, 1924; and an embroidered linen **badge** (French, ca. 1916).

OVER THE DOOR TO THE RIGHT: *The Stream, Valserres*, 1894/95, watercolor on paper, by **Macknight**, purchased from the artist, 1907. BETWEEN THE DOORS, TOP TO BOTTOM: *The Pirouette*, 1904, oil on paper, by **Kronberg**; sepia **landscape on soapstone** (Chinese, 19th c.); *The Fountain*, 1918, watercolor on paper, by **Mower**, depicting Isabella Gardner in Caroline Sinkler's garden, Gloucester, Massachusetts, gift of the artist. Below them is a **writing table** (Italian, 19th c.) supporting a painted metal **box**.

➤ LEAVING THE MACKNIGHT ROOM, TO THE RIGHT:

West Cloister

ON THE NORTH WALL, LEFT OF THE MACKNIGHT ROOM ENTRANCE: tabernacle, ca. 1450, limestone, ascribed to Bartolomeo **Giolfino** (Veronese, ca. 1410–1486). *Christ as the Man of Sorrows* is in the center between *Saints John the Baptist and Julian (?)*. On the pinnacles are the half-figures of the Annunciation with God the Father in the middle. The **lanterns** match those in the East Cloister (p. 26). DIAGONALLY ACROSS, AT THE CORNER OF THE COURT: marble **statue** representing the *Personification of Faith* (Neapolitan, 14th c.), standing on a blue stone **spiral shaft** (Tuscan, 13th–14th c.).

TO THE RIGHT: marble **sarcophagus** depicting *Satyrs and Maenads Gathering Grapes* (Roman, Severan period, 222–235) [probably representing a Bacchic procession]. Sometimes called the "Farnese sarcophagus" for the Palazzo Farnese where it once resided, it was acquired in 1898 through Richard Norton. It is considered one of the finest surviving examples of Roman Imperial sarcophagi.

The marble sarcophagus in the West Cloister depicting *Satyrs and Maenads Gathering Grapes*, 222–235.

ALONG THE OPPOSITE WALL, LEFT TO RIGHT: four **frescoes** transferred to linen. *Mater Dolorosa* and *An Angel Catching the Blood of the Redeemer* (Italian, Lombard, ca. 1425–1475). *The Madonna and Child Enthroned* and *Saint Francis* (Venetian, ca. 1400–1450).

On **columns** (Venetian, 12th c.): stone **heraldic lion** and a **female head** (both Venetian, 15th c.) from balustrades or stair rails. Beside them hangs a bronze **gong** (Japanese, 18th c.).

TO THE LEFT AND ON THE PROJECTING WALL: stone **relief** of the *Madonna and Child* with the arms of the Venier family of Venice (15th c.), purchased from Consiglio Ricchetti, Venice, 1897. BELOW: **sarcophagus** (Roman, ca. 125) with strigilar carving and a nameplate in the shape of a Maltese cross, purchased from Henry Sartorio, Rome, 1923.

UNDER THE STAIRS: Venetian **fountain** (probably 15th c., some parts modern) with various, small Graeco-Roman and Renaissance heads and torsi. UNDER THE STAIR LANDING: fragment of a **tombstone** (Persian, ca. 1475–1490), purchased from Mihran Sivadjian, Paris, 1901, through Ralph Curtis. The carving is in the calligraphic court style of the capitol of Herat at Timurid. What remains of the inscription indicates an epitaph of a martyred prince or holy man and includes "Judgment is to God" (*Qu'ran*, *Sura* 12, verse 66). ON THE FLOOR: small stone **lion** (Venetian, 14th c.).

AT THE SOUTH END AT THE BASE OF THE STAIRS: Istrian stone *Madonna della Ruota della Carità*, 1522, by Giovanni Maria **Mosca** (Paduan, active 1515–1553), with the arms of Paolo da Mônte, purchased from A. Clerle, Venice, 1897. The relief was made for the facade of a building belonging to the Scuola della Carità in Venice, and the *Wheel of Charity*, the Greek cross with concentric circles held by the Madonna, is its adopted symbol.

Beyond the doorway are the Special Exhibition Gallery, Elevator, Rest Rooms, Gift Shop, and Café.

Stairway to the Second Floor

The Istrian stone **stairs** and the marble **balustrade** (Venetian) are copied from a stairway in the former Fondaco dei Turchi, Venice.

SET INTO THE WALL: two marble **slabs** (Venetian, 9th–10th c.), perhaps from the parapet of a choir. Also, six stone cornice **moldings** (Venetian, 11th–12th c.), arranged to form a lintel.

ABOVE: pair of **gate doors** from a temple or shrine, with finely carved panels, and two sets of **sliding doors**, painted on natural cedar, depicting *Plovers* and *A Drinking Tiger* (all Japanese, 18th c.), all purchased from the Bunkio Matsuki sale, Boston, 1903, except the *Tiger*, which came from the Yamanaka sale, Boston, 1902. AT THE HEAD OF THE STAIRS: *Princess Hsi Wang Mu with Her Attendants*, painted wood panel in the shape of an open fan, by Kanō **Yasukuni** (Japanese, 1717–1792), from the Yamanaka sale, Boston, 1902.

Second Floor Stair Hall, North

The **tile floors** here and elsewhere on the second and third floors (see pp. 41 and 88) were made for Isabella Gardner by Henry Chapman **Mercer** (American, 1856–1930). Made at his Moravian Pottery and Tile Works in Doylestown, Pennsylvania, these are based on 14th-century tiles at the Castle Acre Priory, Norfolk, England. Fenway Court was Mercer's first important commission.

Princess Hsi Wang Mu with Her Attendants, by Kanō Yasukuni, at the top of the second floor stairs.

ALONG THE STAIRWELL: iron **grill** and **railing** in two parts, made from a bed (Italian, 17th c.). Other pieces make up the case to the left of the fireplace in the Early Italian Room (see p. 58). IN THE CENTER OF THE LANDING: two large **columns** of pink Carrara marble (Italian, 15th c.).

HIGH ON THE LEFT WALL, ABOVE THE WINDOW: two 19th-century Japanese carved and painted **panels**, made from the stern panels of boats, and a **tapestry**, *Noah Builds the Ark* (Flemish, Brussels, 1650–75). This is one from a set of three in the collection that depicts scenes from the story of Noah (see pp. 111 and 125). Below is an Italian double **choir stall**, originally 15th century, but extensively restored to appear to be 17th century.

OPPOSITE WALL: **tapestry**, *Pleasures of Winter* (probably Flemish, 1675–1700). BELOW: Small carved walnut credence or **cupboard** (Italian, style of the 16th c.). IN THE CORNER TO THE LEFT: stone **lion of Saint Mark**, the patron saint of Venice. The inscription reads "Peace to thee, Mark, my evangelist."

The **door** and **doorway** leading into the Early Italian Room are Florentine, 15th century, purchased from Emilio Costantini, Florence, 1897. Heavily decorated with intarsia work, they are said to have come from the Palazzo del Turco in Borgo SS. Apostoli, Florence.

➤ THROUGH THE DOORWAY:

Early Italian Room

Although small objects in the room are from other parts of the world, and the furniture of different periods, the paintings are all Italian and cover a time span from about 1320 to 1540.

HIGH ON THE SOUTH (RIGHT) WALL: *The Annunciation*, ca. 1385–90, by **Lorenzo di Bicci** (Florentine, active 1370–1427), purchased from Toplady, London, 1901, through Berenson as a work by Agnolo Gaddi. BELOW, RIGHT: *Sacra Conversazione,* ca.

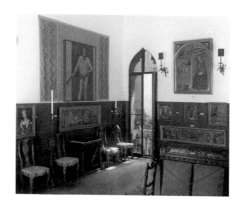

The Early Italian Room, looking toward the Courtyard, with Piero della Francesca's *Hercules* on the wall to the left.

1497–1500, by Andrea **Mantegna** (Mantuan, 1430/31–1506), purchased in Rome, 1899, through Richard Norton. CENTER: *Saint Lucy and Her Mother at Prayer before the Tomb of Saint Agatha,* ca. 1490, by Antonio **Cicognara** (Ferrarese, active 1480–1500), purchased from M. Guggenheim, Venice, 1897, as *Laura and Petrarca,* by an anonymous Paduan artist. LEFT: *The Circumcision,* by Cosimo **Tura** (Ferrarese, ca. 1430–1495), purchased from Contessa Passeri, Rome, 1901, through Richard Norton. BELOW, LEFT: *The Dormition of the Virgin with a Nun,* ca. 1490, by **Giovanni da Rovezzano (?)** (Florentine, ca. 1412–1459). Purchased from J. Eastman Chase, Boston, 1900, as the work of Matteo da Gualdo Tadino. Below it is a modern **cassone** in the style of the 16th century.

TO THE LEFT, ON THE EAST WALL: *A Young Man in a Scarlet Turban,* ca. 1425–27, **attributed to Masaccio** (Florentine, 1401–1427/28), purchased from Emilio Costantini, Florence, 1898, through Bernard Berenson as a work by Masaccio.

The four tall iron **torchères** along the East Wall are Spanish, 14th–15th century, purchased from Galeries Heilbronner, Paris, 1906.

HIGH ON THE WALL: *Hercules*, ca. 1475, fresco, by **Piero della Francesca** (Umbrian, ca. 1416–1492), purchased from Elia Volpi, Florence, 1906, through Joseph Lindon Smith. It came from the artist's own home in Borgo Sansepolcro. BELOW: the long panel—*The Triumphs of Fame, Time and Eternity*—and its companion panel—*The Triumphs of Love, Chastity and Death*—to the left of the doorway are both ca. 1448, by Francesco **Pesellino** (Florentine, 1422–1457). They illustrate a poetic moral allegory by Petrarch. Reading both from left to right: Love is defeated by Chastity, Chastity by Death, Death by Fame, Fame by Time, and Time is triumphed over by Eternity. At the extreme right of the second panel, God and the angels preside in Eternity over a new earth. Probably made for the marriage of Piero de' Medici (father of Lorenzo the Magnificent) to Lucrezia Tornabuoni. Purchased from the estate of J. F. Austen, Kent, 1897, through Bernard Berenson.

IN THE CASE ON THE TABLE: Chinese **rosaries** and various other beads. The eleven lemon **amber beads** were a gift of Thomas Whittemore, 1921.

TO THE RIGHT OF THE DOORWAY: *A Lady with a Nosegay*, ca. 1525, by Francesco Ubertini, called **Bacchiacca** (Florentine, 1494–1557), purchased from Carlo Coppoli, Florence, 1901, through Bernard Berenson; and TO THE LEFT: *A Boy in a Scarlet Cap*, by **Lorenzo di Credi** (Florentine, ca. 1448–1537), purchased from Sulley & Co., London, 1914, through Berenson. ABOVE THE DOORWAY: framed **armorial motif** (Italian, 1700–1800); the **frame** originally held *The Concert*, by Jan Vermeer (see p. 85) and was changed by Isabella Gardner shortly after its purchase.

ABOVE THE FAR PESELLINO PANEL: polyptych, *The Madonna and Child with Saints Paul, Lucy, Catherine, and John the Baptist*, ca. 1320, by **Simone Martini** (Sienese, ca. 1283–1344). The altarpiece comes from the church of the Servites at Orvieto. Purchased from the Mazzochi heirs in 1899 by Berenson and

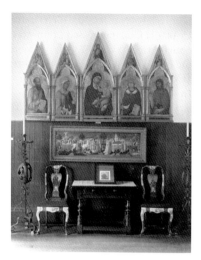

The Early Italian Room, looking toward Simone Martini's polyptych of the *Madonna and Child with Saints Paul, Lucy, Catherine, and John the Baptist.*

sold to Isabella Gardner that same year. BELOW: walnut **table** (Italian, 17th c.). ON THE TABLE: *Portrait of a Seated Turkish Scribe or Artist,* ca. 1479/80, pen and gouache on paper, by Gentile **Bellini** (Venetian, ca. 1430–1507), probably at the court of Sultan Mohammed II. The inscription, upper right, is a Persian identification of the painter as famous among the Franks. Purchased from a Turkish family, 1907, through Anders Zorn.

TO THE LEFT: *A Bishop Saint,* by Michele **Giambono** (Venetian, active 1420–1452), purchased from M. Guggenheim, Venice, 1897.

ON THE NORTH WALL, RIGHT OF THE WINDOW, ABOVE: *The Madonna and Child before a Rose Hedge,* in the style of the early 15th century, by a **follower of Gentile da Fabriano** (Umbrian, 15th c.). The frame may be original. BELOW: *The Crucifixion,* late 15th century, by **Alesso di Benozzo** di Lese di Sandro (Tuscan, 1473–1528), purchased from Antonio Grandi, Milan, 1906, as a Florentine work.

BETWEEN THE WINDOWS, ON AN EASEL: triangular tempera **panel**, a pinnacle from a larger altarpiece, *Saint Elizabeth of Hungary*, by Ambrogio **Lorenzetti** (Sienese, active 1319–1347), gift of Mr. and Mrs. John Jay Chapman in memory of their son Victor, 1917.

ON THE WALL BEHIND: *Saint Anthony Abbot with Four Angels*, by Niccolò di Pietro **Gerini** (Florentine, active 1368–1416), purchased from the Galleria Sangiorgi, Rome, 1906, as *Saint Jerome* by Orcagna.

TO THE LEFT, ON AN EASEL: *The Madonna Enthroned with Saints and Angels*, by Bartolommeo **Bulgarini** (Sienese, active 1337–1378), purchased from Mrs. Charles Bruen Perkins, 1911. In front of it, on a table designed by Elsie **de Wolfe** (American, 1865–1950) are two silver **candlesticks** (Indian, 19th c.).

TO THE LEFT OF THE WINDOW: ABOVE: **altarpiece** and **predella**: *The Madonna and Child* and *The Crucifixion,* second half of the 14th century, by an **unknown Venetian painter**. BELOW: *The Crucifixion with Saints,* triptych, by Andrea **Vanni** (Sienese, active 1353–1413/14), purchased from Attilio Simonetti, Rome, 1902, through Joseph Lindon Smith without attribution to any artist. In the upper portion of the wings is an Annunciation. In the lower parts, left, are saints Stephen and Anthony Abbot, and, right, saints Catherine and John the Baptist.

WEST WALL, TO THE RIGHT OF THE WINDOW: ABOVE: *The Madonna and Child, with Saints Matthew and Francis,* by **Bicci di Lorenzo** (Florentine, 1373–1472), purchased by Joseph Lindon Smith in Florence before 1899 and purchased from him in 1912. BELOW: *The Madonna of Humility with Saints,* 15th c., triptych, by **Giovanni di Francia (?)** (Venetian, 15th c.).

TO THE LEFT OF THE WINDOW: ABOVE: *Death and Assumption of the Virgin,* ca. 1432, by **Fra Angelico** (Fiesole, 1400–1455), purchased from Colnaghi, London, 1899, through Berenson. BELOW: *The Madonna and Child,* ca. 1490s, by **Pintoricchio** (Benedetto di

Death and Assumption of the Virgin, by Fra Angelico.

Sigismondo Pandolfo Malatesta, Duke of Rimini, bronze medal by Pisanello, ca. 1445.

Biagio) (Umbrian, 1454–1513), purchased from Berenson, 1902, who had acquired it from Emilio Costantini, Florence.

To the right of the fireplace: *The Madonna and Child with a Goldfinch,* by Bernardo **Daddi** (Florentine, died 1348), purchased from Sulley & Co., London, 1914, through Berenson. In the case below: various pieces of **metalwork**, mostly French, and four Italian **medals**. Three by **Pisanello** (Italian, 1395–1455) are: *Filippo Maria Visconti, Duke of Milan,* ca. 1440/41, lead; *Sigismondo Pandolfo Malatesta, Duke of Rimini,* ca. 1445, bronze; and *Niccolò Piccinino of Perugia,* ca. 1441, bronze. All were purchased from Gustave Dreyfus, Paris, 1893, through Ralph Wormeley Curtis. One by **Matteo de' Pasti** (Italian, died 1467) is: *Isotta degli Atti, Fourth Wife of Sigismondo Malatesta,* 1446, bronze, acquired from a Frankfurt dealer through Gustave Dreyfus and Ralph Curtis, 1893. The white medal is a ceramic copy.

Flanking the fireplace: pair of Japanese *rintō* (temple lamps) suspended from a pair of dragon-head **ryūzu**, originally for hanging Buddhist ornaments or banners.

To the left of the fireplace: *The Infant Christ Disputing in the Temple,* ca. 1460, by **Giovanni di Paolo** (Sienese, active 1417–1482/83). Sold by Agnew & Sons, London, 1908, through Berenson.

ABOVE THE FIREPLACE: *Three Women*, by an **unknown painter** (possibly Milanese, 15th c.), purchased from Antonio Carrer, Venice, 1897, through Berenson, as a work by Bramantino.

IN THE GLASS CABINET (see p. 52): TOP SHELF: alabaster **canopic jar** (Egyptian, New Kingdom or later, 1570–1085 B.C.), purchased through Joseph Lindon Smith, Cairo, 1913, and bronze **figure** of *Harpocrates* (Egyptian, probably Ptolemaic, or Graeco-Roman), provenance unknown. SECOND SHELF: ivory **stand**, stained green, and blue glass **vase** with applied reliefs (Chinese, late 18th c.); lustre-ware **plate** depicting a scene of two lovers (Persian, Kashan, ca. 1210), purchased from H. K. Kevorkian, Boston, 1912; and a pewter **ewer** (Chinese, early 19th c.) in the form of a Taoist immortal. THIRD SHELF: steatite **seal** (Chinese, 19th c.) that reads "The Bamboo Announces Peace" (All is well at home); blue-green jade *ju-i* (scepter) and gilt metal *ju-i* with three decorated lapis lazuli plates (both Chinese, late 18th c.). In the form of back-scratchers, ju-i express good wishes on special occasions. Two gilt bronze **bears** (Chinese, early Han period, ca. 1st c.), purchased from M. Bing, Paris, 1914, through Berenson. BOTTOM SHELF: **incense burners**: one granite in the form of an elephant (Korean, 18th c.); one bronze in the form of a *Li-Ting* (Chinese, late 18th c.); and one gilt in the form of a *Fang-Ting* (Chinese, late 18th c.).

IN THE WINDOW: *The Madonna of Humility, with a Donor*, in the **style of Gentile da Fabriano** (Umbrian, 15th c.), purchased from Joseph Lindon Smith, after 1909.

BEHIND THE PAINTING AND CURTAIN: A **cabinet** (possibly Venetian, 18th c.) supports a Japanese **temple table** (mid-18th c.) and an **amulet box** (early 19th c.). On the temple table is an Imbé-ware **figure** of the Chinese poet Li Po, signed *Fushūdō* with the seal of Sadakata (Japanese, Bizen, early 19th c.). Purchased at the Bunkio Matsuki sale, Boston, 1901.

IN FRONT OF THE FIREPLACE: pair of high-back **benches** (Italian, 19th c.) were made from a bed. Around the benches and the

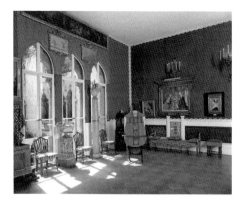

The Raphael Room, looking to the Southwest, with Piermatteo d'Amelia's *Annunciation* on the wall to the right.

room are a set of twelve lacquered, painted **side chairs** (Venetian, ca. 1740).

➤ THROUGH THE EASTERN DOORWAY:

Raphael Room

RIGHT, TOWARD THE COURT: *A Woman in Green and Crimson*, ca. 1490s, by Piero del **Pollaiuolo** (Florentine, ca. 1443–1496), acquired from Duveen Brothers, 1907, through Bernard Berenson, as a work by Antonio del Pollaiuolo. BELOW: painted **panel** from an Italian cassone, second half of the 15th century.

ABOVE, CENTER: *The Annunciation*, ca. 1480, by **Piermatteo d'Amelia** (Umbrian, active ca. 1450–1500), purchased from Colnaghi, London, 1900, through Bernard Berenson, as a work by Fiorenzo di Lorenzo. From the chapel of the Porziuncula at Assisi, hung at S. Maria degli Angeli.

IN FRONT: **settee** (Venetian, 18th c.), combining styles of both Louis XV and XVI. ON THE WALL BEHIND: **embroidery** panel (Holy Roman Empire, 1675–1750) with the double-headed eagle and crown of the Hapsburg family.

ABOVE, LEFT: *The Madonna and Child before a Curtained Landscape,* early 16th c., from the **studio of Giovanni Battista Cima da Conegliano** (Venetian, died ca. 1518), purchased from Colnaghi, London, 1897, through Bernard Berenson, as a work by Cima. It is regarded as a contemporary copy of a painting now in the National Museum of Wales, Cardiff. BELOW: *A Story from Antiquity,* by Giovanni Maria **Falconetti** (Veronese, ca. 1468–1534). Painted in grisaille, the panel was once the front of a cassone.

IN THE CORNER: An alabaster **Saint Sebastian** (Italian, 16th or 17th c.) stands on a 1st-century Roman base. Both are supported by a 19th-century **column** in the style of the Italian Renaissance.

ON A STAND, AWAY FROM THE WALLS: **chasuble** (Florentine, ca. 1375–1425) with an orphrey from a cope showing scenes from the life of Christ.

SOUTH WALL:

TO THE RIGHT OF THE WINDOWS: black enameled **cabinet** (Italian, 19th c.), with mother-of-pearl inlay. ON THE CABINET: marble **foot** (Italian, 16th c.).

BY THE COURT WINDOWS, AND AROUND THE ROOM: thirteen **chairs** (Italian, late 18th c.) with shield backs in the Hepplewhite style. There is also a matching **sofa** along the table in the center of the room.

ON A MARBLE COLUMN BY THE WINDOW: terra-cotta **vase** (South Italian, 3rd c. B.C.), said to have come from Canosa in Apulia. Medusa is represented on the front, and three figures of Nike are on the top.

AT THE LEFT, BETWEEN TWO WINDOWS: marble **bowl** (Roman, Imperial period, restored in the 16th c.) with handles in the form of lions or panthers. Supported by a *cippus* (household altar) with reliefs of *Pan Dancing with Maenads* (Roman, 2nd or 3rd c.).

BETWEEN TWO WINDOWS: **cassone** (North Italian, late 15th c.) with three painted panels depicting historical or legendary

incidents. INSIDE THE CASSONE: three **chasubles** (Italian, 16th–18th c.), made of brocatelle and brocaded damask. DRAPED OVER THE LID: silk velvet **cope** (Italian, ca. 1550–1600), with pomegranate design. ON THE WALL ABOVE: two *Heroes of Antiquity*, ca. 1496, by **Neroccio** di Bartolomeo de' Landi (Sienese, 1447–1500).

IN THE CABINET TO THE LEFT: miniature Greek (Attic) **vase** with black-figure decoration; three **figurines** in the Tanagra style (two of seated women are modern copies, gifts of William Amory Gardner, ca. 1903, and the standing woman is Greek, 4th–3rd c. B.C.); and two **fragments of fresco** (Roman, 1st c.), found at Boscoreale.

ABOVE, ON THE WALL: **curtain** (Italian, 1650–1725) with an attached valence.

IN THE CORNER: *The Madonna with the Sleeping Child on a Parapet*, ca. early 1470s, by Giovanni **Bellini** (Venetian, ca. 1430–1516), purchased from Henry Reinhardt & Son, New York, 1921, through Bernard Berenson and Walter Fearon. ON THE FLOOR BELOW: bronze **bowl** (Roman-Pompeian, 1st c. B.C.–2nd c. A.D.) with snake-shaped handles, said to have been found at Pompeii.

EAST WALL:

The Tragedy of Lucretia, ca. 1500/01, by Alessandro Filipepi, called Sandro **Botticelli** (Florentine, 1445–1510), purchased from the Earl of Ashburnham, 1894, through Bernard Berenson. Lucretia's suicide after her rape by the son of the Roman tyrant, Tarquinus Superbus, resulted in rebellion and the establishment of a Roman Republic.

BELOW: **cassone** (Sienese, third quarter of the 15th c.), purchased from G. Teunissen, The Hague, 1894, through Ralph Curtis. Made for a marriage between the Piccolomini family of Pope Pius II (on the throne from 1458 to 1462), and the Todeschini family (whose arms appear on the right and left, respectively). INSIDE THE CASSONE: a rare fourteen-string **guitar** called a *chitarra battente*, with bone inlay (Roman or Paduan,

17th or early 18th c.), signed: *C. Mosca-Cavelli*. A folk instrument strung with metal strings that attach to the end of the body instead of the bridge, it was played with a plectrum.

ABOVE THE DOORWAY: *The Virgin and Child, Saints George, Martin, and Anthony Abbot*, ca. 1395, by Francesc **Comes** (Spanish, active 1392–1415), purchased from Durand-Ruel, New York, 1901.

TO THE LEFT: *Saint George and the Dragon,* 1470, by Carlo **Crivelli** (Venetian, active 1457–1495), purchased from Colnaghi, London, 1897, through Bernard Berenson. Once part of a large altarpiece painted in 1470 for the parish church at Porto S. Giorgio on the Adriatic.

IN THE CENTER: *Madonna and Child Sitting on a Parapet with a Goldfinch*, ca. 1510–17, by Francesco Raibolini, called **Il Francia** (Bolognese, 1450–1517), purchased from Emilio Costantini, Florence, 1899, through Bernard Berenson. ON THE WALL BENEATH THE PAINTINGS: silk satin fragments of **furnishing borders** (probably Italian, ca. 1675–1750). ON THE TABLE BELOW: Sheffield **candelabrum** (English, 18th c.), one of a pair (the

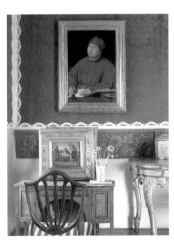

Portrait of Tommaso Inghirami, by Raphael and his studio (on the wall) and Raphael's early *Lamentation over the Dead Christ* (on the desk).

other is across the room on the large commode) and a terra-cotta **cinerarium** (Italo-Etruscan, ca. 150 B.C.).

FAR LEFT: *Portrait of Tommaso Inghirami*, ca. 1516, by Raffaello Sanzio, called **Raphael** (Marchigian, 1483–1520), **and studio**, purchased from the Inghirami family, Volterra, 1898, through Bernard Berenson.

ON THE EASEL AT THE DESK: *Lamentation over the Dead Christ*, ca. 1504, by **Raphael**, purchased from Colnaghi, London, 1900, through Bernard Berenson. From the predella of a large altar-piece done for the convent of S. Antonio at Perugia.

OPPOSITE, ON THE PROJECTING SIDE OF THE FIREPLACE: majolica **plate** (Umbrian, before 1550), representing the Nativity.

The **fireplace** canopy is modern, and the apron (North Italian, 15th c.) is inscribed in Latin: *MOTU ET LUMINE* (from motion and light). TO EITHER SIDE OF THE FIREPLACE: red velvet **hangings** with the embroidered arms of Cardinal Hohenlohe (Prince Gustav Adolf Hohenlohe-Schillingsfürst, 1823–1896), an important figure at the court of Pope Pius IX. Purchased from Galleria Sangiorgi, Rome, 1899.

WEST WALL:

Virgin and Child with the Young Saint John the Baptist, ca. 1470–80, by Francesco **Botticini** (Florentine, 1446–1497), purchased from Lawrie & Co., London, 1901, through Bernard Berenson.

ALONG THE WALL BELOW: **commode** and a pair of **cabinets** in a similar style (Venetian, late 17th–18th c.).

ABOVE, IN THE CENTER: *Madonna and Child* (Italian, late 15th c.), **influenced by Andrea Mantegna**, purchased from Vincenzo Favenza, Venice, as a work by Antonio della Corna. Given to Isabella Gardner by her husband, John L. Gardner, Christmas 1892. BELOW IT, ON THE COMMODE: marble **head of a goddess** (Graeco-Roman, 1st or 2nd c., imitating the Archaistic style of the 6th c. B.C.).

AT THE LEFT: *Madonna and Child, with a Swallow,* by Francesco **Pesellino** (Florentine, 1422–1457), purchased from the estate of Frederick R. Leyland, London, 1892, through B. F. Stevens, as a work by Filippo Lippi.

ABOVE THE DOORWAY: *The Adoration of the Statue of Nebuchadnezzar,* by an **unknown painter** (Venetian, probably first half of the 16th c.), purchased from Vincenzo Favenza, Venice, 1892. The story is from the Book of Daniel, chapter 3.

IN THE CENTER OF THE ROOM: **refectory table** (Italian, style of the 17th c.). ON THE TABLE: **statue** of *Silenus with Winesack* (Graeco-Roman, 2nd–3rd c.); a bronze **ornament** or buckle (Ancient Caucasian or Sarmathian, 2nd c. B.C.–6th c. A.D.), gift of Thomas Whittemore, 1921; a *zwischengoldglass* (gold between layers of glass) **tumbler** (probably Venetian, late 18th c.) from the set in the Titian Room (see p. 99); and a bronze **mortar and pestle**. The sticks in the glass may be tapers for lighting candles.

ABOVE THE WINDOWS AROUND THE ROOM: four **mirrors** (Venetian, 19th c.), engraved with mythological figures.

➤ THROUGH THE DOOR IN THE EAST WALL:

Short Gallery

The **door** is Italian, painted and gilt in the style of the 17th century. OVER THIS DOOR AND THE ONE OPPOSITE: eight *Scenes from the Metamorphoses of Ovid* in the **style of Veronese** (Venetian, late 16th or 17th c.), purchased from Dino Barozzi, Venice, 1899.

BEHIND THE DOOR, ALONG THE WEST WALL: the tall **case** (see Yellow Room, p. 19) contains various **textiles**, mostly 15th- and 16th-century Italian fabrics acquired in Florence and Venice. To safely display an important collection that is brittle and sensitive to light damage, the Museum periodically rotates the visible contents of the cases. (Also see the Veronese Room lace cases, p. 95.) Gardner's textile collection was quite large and

filled many drawers in the galleries, as well as these showcases. Gardner often changed and added to her textile displays.

<small>Continuing around the room from left to right:</small>

Portrait of Mary Brough Stewart, by an **unknown painter** (Scottish, 18th c.). The sitter is Isabella Gardner's great-grand-mother (1744–1804), whose fourth son, James (1778–1813), emigrated from Scotland to America and married Isabella Tod, whose portrait is in the corner to the right.

<small>To the right, at the top:</small> *Isabella Stewart Gardner,* 1917, by Martin **Mower** (American, 1870–1960), gift of the artist, 1917. Painted from a photograph taken by O. Rosenheim, London, 1907. <small>Below:</small> *Winter* and *Summer*, 1802, colored mezzotints, by William **Barnard** (English, 1774–1849), after paintings by George Morland.

The brass-bound inlaid **folding table** is Italian, late 18th century. <small>On the table:</small> marble **vase** (Italian, 18th c.).

<small>In the corner:</small> *Portrait of Isabella Tod Stewart*, 1837, by Thomas **Sully** (American, 1783–1872). Isabella Tod (1778–1848) was the daughter of David Tod, who had come from England in 1761. Her son, David, married Adelia Smith in 1839, and their daugh-ter was Isabella Stewart Gardner. <small>Below the portrait:</small> bloc-front Spanish mahogany **chest-on-chest**, late 18th-century New England origin, which once belonged to Isabella Tod Stewart.

<small>On a stand:</small> *A Gondolier*, ca. 1514–20, from the **workshop of Vittore Carpaccio** (Venetian, ca. 1460/65–ca. 1526), purchased from the sale of the Robinson collection, Agnew & Sons, London, 1902.

<small>To the right of the window:</small> *The Flax Spinner*, 1868/69, etch-ing (state V), by Jean François **Millet** (French, 1814–1875), pur-chased from the Mary J. Morgan collection, New York, 1886.

<small>At the right:</small> carved teakwood Chinese **cabinet**, containing a variety of articles, mainly 19th-century Chinese. <small>On the middle</small>

Mrs. Gardner in Venice, by Anders Zorn.

SHELF: two Turkish **plates** (Iznik, late 17th c.). ON THE BOTTOM SHELF: *jardinière* (planter) (French, Parisian, ca. 1790–1800).

ABOVE THE CABINET: *Portrait of John Lowell Gardner,* 1895, by Antonio **Mancini** (Italian, 1852–1930). Jack Gardner (1837–1898) was a trustee and the treasurer of the Museum of Fine Arts, Boston, and was prominent in business and public undertakings. He sat for this portrait in Venice.

TO THE RIGHT, ON THE EAST WALL: *Mrs. Gardner in Venice,* 1894, by Anders **Zorn** (Swedish, 1860–1920). Though painted at home in his studio, it depicts Gardner at the Palazzo Barbaro, Venice, where the Zorns and the Gardners spent part of a summer together.

IN THE CABINET BELOW: a variety of objects and some family silver. Of particular interest: oval jade **tray** (Mughal, 18th c.); bronze **figure** of Vishnu (Khmer, 12th–14th c.) given to Gardner at Angkor Thom in 1883; a silver **prayer wheel** with a wooden handle (Tibetan, 18th c.) containing the prayer formula *Om-ma-ni-pad-me Hūm* (Om! The Jewel of the Lotus! Hūm!); a small bronze *Hathor* **cow** (Hellenistic or Graeco-Roman), gift of William Amory Gardner; a pale-green jade **statuette**

(Chinese, 18th c.) of *Hsi Wang Mu*, the Taoist Queen of the West, with an attendant and recumbent stag; several enamel and silver **boxes** (Chinese, 19th c.) for opium; two silver **trophies** awarded to Gardner's grandmother by the New York Agricultural Society (1821, pitcher; 1828, mug); and a Hispano-Moresque **plate** (Valencian, 18th c.) in a copper luster, depicting birds, ferns, and fish. ALONG THE FRONT OF THE CABINETS: chair-back **settee** (English, 18th c.). Five early-19th-c. Italian **chairs** combining English Sheraton and French Empire styles are also in this room, with a sixth in the Macknight Room, p. 45.

ON THE WALL TO THE RIGHT, TOP TO BOTTOM: *Study for a Portrait of William Amory Gardner, 1873,* by William Morris **Hunt** (American, 1824–1879). One of the three nephews that Isabella and Jack Gardner helped to raise after they were orphaned. This portrait is a study for an oil painting that hangs at the Groton School, which William Amory Gardner (1863–1930) helped to found in 1884. *George Washington*, stipple and line engraving, by David **Edwin** (English-American, 1776–1841), after Rembrandt Peale. *Benjamin Franklin*, watercolor, by an **unknown painter** (American or French, late 18th c.).

Michelangelo's
Pietà.

Tibetan
prayer wheel,
18th century

Nessus the Centaur Abducting Deianira, published 1787, engraved by Francesco **Bartolozzi** (Italian, 1727–1815), after a design by Giovanni Battista Cipriani.

ABOVE, RIGHT: *The Casa Loredan, Venice*, 1850, by John **Ruskin** (English, 1819–1900). BELOW: **secretary-bookcase** (English, late 18th c.); the carving on the drop front is not original.

TO THE RIGHT OF THE DOOR, ON THE SIDE OF THE CUPBOARD: *A Woman with a Dog* and *A Woman Threading a Needle*, two dry-points by Paul-César **Helleu** (French, 1859–1927), and *A Girl with a Cigarette, II*, 1891, etching (state I), by **Zorn**.

ALONG THE REST OF THE WALL: four large **cupboards** containing most of the prints and drawings in the collection. Designed by Isabella Gardner, the doors open to panels, enabling 183 works to be displayed along a short length of wall.

These include old master drawings such as the *Pietà*, by **Michelangelo** Buonarroti (Florentine, 1475–1564); *Pope Sylvester I Carried in the Sedia Gestatoria, with His Retinue*, by Raffaello Sanzio, called **Raphael** (Marchigian, 1483–1520); *Christ Embracing John the Baptist*, by Filippino **Lippi** (Florentine, 1457/58–1504); and a *Study of a Figure from the Resurrection Altarpiece*, by Agnolo **Bronzino** (Florentine, 1503–1572).

Three Heads of Zorah, by Henri Matisse.

James A. McNeill
Whistler's
lithograph,
The Sisters.

Among works from the 19th and 20th centuries are five by
Henri **Matisse** (French, 1869–1954), thirty-seven prints by
James A. McNeill **Whistler** (American, 1834–1903), eighty-two
by **Zorn**, two costume designs by Leon **Bakst** (Russian,
1866–1924), six drawings by Hilaire-Germain-Edgar **Degas**
(French, 1834–1917), and a portrait sketch of Isabella Gardner
by John Singer **Sargent** (American, 1856–1925).

ABOVE THE CUPBOARD: gilt **wood carving** (Japanese, 19th c.)
and two paintings **attributed to Giuseppe Zais** (Venetian,
1709–1784): *By the Stream* and *At the Fountain.*

IN THE CORNER: embroidered with silk and gilt yarns is a silk
flag, 1813/14, bearing the insignia of the First Regiment of
Grenadiers of Foot of Napoleon's Imperial Guard, purchased
from Sypher & Co., New York, 1880. Displayed in a hinged frame,
on the flag's reverse is a list of battles fought by this regiment.

ON EITHER SIDE OF THE DOOR: two French Empire **cabinets**
(early 19th c.), with marble tops; the right-hand case contains
mementos of Napoleon, including some signed documents,
and a portrait by François Seraphim **Delpech** (French,
1778–1825). Above, an engraving of *Ragioni di Stato*, by
Francesco **Didioni** (Italian, 1859–1895), depicts Napoleon and
Josephine. Above the doorway is a **panel** from the set of wood-
work described in the Little Salon, p. 70.

ALONG THE WEST WALL: four **side chairs** (English, late 18th c.), all in the Hepplewhite style. Three have three splats in the form of Prince of Wales feathers tied in a knot, one has five splats in the form of a tied plume. The long glass **case** contains another portion of Isabella Gardner's textile collection (see p. 64, in this gallery). ABOVE THE CASE: *Decorating a Shrine*, ca. 1864, by Francesca **Alexander** (American, 1837–1917); a framed velvet furnishing and garment **fabric** (Italian, 1450–1500); and *A Lady of the Russell Family*, ca. 1760, **attributed to Joseph Blackburn** (American, active 1753–63).

➤ THROUGH THE DOOR IN THE EAST WALL:

Little Salon

Much of the furniture and decorative woodwork in this room is a Venetian version of the French Louis XV style (18th c.),

The Little Salon, looking toward the fireplace, with François Boucher's *Car of Venus* on the left.

Detail of *The Surprise*, a French tapestry from Paris, 1625–50.

upholstered in the Victorian manner contemporary to Isabella Stewart Gardner. The more notable furnishings include the large **mirror** between two **windows** with decorated lower **panels**; the smaller **mirror** over the fireplace; the **window paneling** and **molding** in the East Wall; the gilt **wood carving** above it; and the two concave **doors**, in the northeast and southeast corners of the room, with the concave **panels** beneath them. The **panels** above the door to the Tapestry Room here and in the Short Gallery are also of this set, purchased from Antonio Settini in Venice in 1897, and are all fittings from a Venetian palazzo, supposedly the Morosini-Gattembourg.

The four **tapestries** depicting gardens with figures are called the *Château and Garden Series*. Those on the South and West walls, *A Musical Party* and *Strolling and Seated Lovers*, are Flemish (Brussels, 1585–1600), made in the shop of Jacob Guebels; while the two on the East Wall, *Boating and Hunting Parties* and *The Surprise*, are French (Paris, 1625–50), made in the shop of one of the Flemish weavers, François de la Planche or Philippe de Maecht. The set was purchased from Charles Ffoulke in 1903 and originally belonged to Cardinal Antonio Barberini, nephew of Pope Urban VIII and Grand Prior of France.

BEHIND THE DOOR: ON THE WALL: A *Nymph Embracing a Herm of
Pan*, colored mezzotint, by Baron Auguste **Desnoyers** (French,
1779–1857), a gift of Ralph Curtis; and *Venus Recumbent*, 1785,
colored mezzotint, by Francesco **Bartolozzi** (Italian, 1727–1815),
after a painting by Annibale Carracci. Bequest of H. Louisa
Brown, 1883, supposedly hung in Lord Byron's chateau at Genoa.
The marquetry **vitrines** are probably Italian, 18th century.

The Car of Venus, by François **Boucher** (French, 1703–1770), pur-
chased from Wildenstein, Paris, 1902, through Ralph Curtis and
Fernand Robert. This is probably cut down from a larger com-
position. The carved gilt **frame** is a good example of early Louis
XV design. ON EITHER SIDE OF THE PAINTING: pair of Meissen
sconces (Dresden, 19th c.), painted with fashionably dressed
people in a landscape. BELOW: small oval tapestry of *Amorino
Offering Flowers to a Sleeping Nymph*, in the **style of François
Boucher** (French, ca. 1755–75). BELOW, ON THE TABLE: 18th-cen-
tury Meissen **clock** and two **candlesticks**. The clock movement
is by Charles **Baltazar** (French, Parisian, early 18th c.).

ON THE MANTEL IN THE CORNER: late 18th- and early 19th-century
Meissen **birds**; the blue jay on the far right is supposed to have
come from the collection of Ludwig II of Bavaria. ABOVE: early
19th-century **clock** in an Italian revival of the Louis XV style,
incorporating Louis XVI and Empire styles as well.

By the windows on either side of the large mirror are two
dummy boards, a boy (England or the Netherlands, ca. 1700)
and a girl (19th c.). Also on either side of the mirror are two
cabinets (North Italian, 18th c. style). On them are two **minia-
ture gardens** (Chinese, late 18th c.), made of ceramic, jade, and
other stones. In front of the mirror in the center is a **daybed**
(Italian, middle of the 18th c.). Beside the daybed are two **arm-
chairs** (Italian, late 18th c., in the Louis XVI style), from a set of
eleven pieces of furniture in the room. The set also includes

four **side chairs**, a **sofa**, and four **armchairs**. All were purchased from Dino Barozzi, Venice, 1906, and all are upholstered in a Victorian style contemporary to Isabella Gardner.

IN THE NORTHEAST CORNER: pedal harp, made by George **Blaichard** (French, ca. 1800–25); a *monocorde à clavier* (keyed monochord), made by Marie Joseph Nicolas **Poussot** (French, after 1886); and a spinet, possibly the **school of Stephen Keene** (English, ca. 1680). The **writing table** is English, 18th century. On it are an assortment of desk implements and souvenirs.

ON THE TABLE BY THE WINDOW: Chinese and Italian **porcelain**: several of the pieces were gifts from friends. The purple glass **plate** (Chinese, 19th c.) was a gift from Henry Davis Sleeper, the brass **box** (probably Russian, provincial) from Harold Jefferson Coolidge, and the elliptical painted wood **box** (English, 18th c.) from Archibald Cary Coolidge.

IN THE SOUTHEAST CORNER: gilt **vitrine** (Italian, early 19th c.). The vitrine contains numerous small objects, mostly gifts from friends. These include: TOP: handmade, silver **"lucky bird,"** from Clara Bowdoin Winthrop, 1921; a jointed silver **fish** (German, 19th c.), from Mrs. George Howe, Easter 1919; silver shrine with *Nyoirin Kwannon*, a bodhisattva known as the "omnipotent one," by Shōami **Katsuyoshi** (Japanese, late 19th c.), from William John Gunn, ca. 1920; a tortoiseshell **snuffbox** with the likeness of Alexander III of Russia, from Catherine Peabody Gardner, 1878; and a silver **box** (Japanese, dated 1894) shaped like a rock, from Kojiro Tomita, ca. 1909.

MIDDLE: a purple morocco **case** containing a reliquary with a fragment of bone said to be that of a saint, from Mrs. Fiske Warren, Christmas 1923; a bronze **Byzantine coin** from the reign of Emperor John II (1118–1143) and a silver **Greek coin** (Athens, 365–359 B.C.) from Matthew Stewart Prichard; a bronze **Roman coin** with the bust of Trajan, from Alfred Fondacaro, 1923; a **locket** containing a four-leaf clover found here during the construction of the building;

and two **miniature lutes** (Italian, 16th c.), one from Luigi Monti, 1883.

IN THE FLAT CASE AT THE BOTTOM: several Japanese *inrō* (medicine cases) ranging from the 18th to the 19th century; the gold lacquered one with the red *netsuke* (a toggle used to fasten a pouch or purse on a kimono sash) in the form of an elephant was a birthday gift from Rudolph Schirmer, 1909. The small gilt **statue** (Japanese, early 19th c.) of *Kwannon*, a bodhisattva known as the "merciful one," is made from a cake of ink. Okakura Kakuzo gave the statue to Okabé Kakuya, who gave it to Gardner in 1910.

IN THE SOUTHWEST CORNER: **vitrine** (Spanish, 18th c.), gift of Denman Ross. TOP SHELF: four **figure groups** in creamware (French, 18th c.); two more are on the middle shelf. Meissen **mirror** and two **birds** (Dresden, 17th c.); small Sèvres **cup and saucer**, in the *Gobelet Bouret* form, painted in 1756 by Vincent **Taillandier** (active in Sèvres, 1753–90) and reputed to be from the collection of King Ludwig of Bavaria. SECOND SHELF: silver **chopsticks** mounted on a knife with a mother-of-pearl handle and **scabbard** (Japanese, early 19th c.), gift of Denman Ross, Christmas 1923; Wedgwood **castor** in Queen's ware (18th c.); white jade **cup and saucer** (Mughal, late 18th c.); lapis lazuli **cup and saucer with lid** (Indian, 19th c.); octagonal **miniature** of *Marie-Antoinette*, ca. 1775; miniature *Portrait of a Man*, which is sometimes identified as Prince Joseph Anton Poniatowsky (1763–1813) and which has been **attributed to Jean-Baptiste Isabey** (French, 1767–1855). THIRD SHELF: Meissen **figurine** of a shepherdess (mid-19th c.); white openwork creamware **fruit basket** and **tray** (English, Staffordshire or Yorkshire, ca. 1780); **furnishing fabric**, embroidered with a figure of *Flora* (French, 1675–1725).

The **benches** on either side of the cabinet are made from a bed that goes with woodwork comprising the room itself.

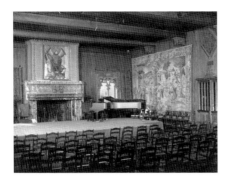

The Tapestry Room, looking toward the fireplace, with Pere García de Benabarre's *Saint Michael* above it.

➤ THROUGH THE DOOR IN THE SOUTH WALL:

Tapestry Room

This largest room in Fenway Court is the concert and lecture hall.

The **tapestries** were woven at Brussels in the mid-16th century. The set of five with a Latin inscription at the top depicts scenes from the life of Abraham; the other set portrays scenes in the life of Cyrus the Great as described by Herodotus's *History* (Book I). In accordance with artistic convention, the settings and costumes in the *Cyrus Series* are contemporary to the manufacture of the tapestries. The costumes in the *Abraham Series* reflect the artist's conception of Old Testament dress. All of them were in the Barberini collection and were purchased from Charles Ffoulke in 1906. The tapestries are arranged in a manner selected by Isabella Stewart Gardner and are not in narrative sequence.

The narrative sequence for the *Cyrus Series* is:

I. *King Astyages Commands Harpagos to Take the Infant Cyrus Away and Slay Him* (*History*, I:107–113) [West Wall, South end]

II. *A Messenger from Harpagos Brings Cyrus a Letter Concealed in a Dead Hare* (I:123–125) [East Wall, North end]

III. *King Astyages Places Harpagos in Command of His Army* (I:127) [West Wall, far right of the large exit]

IV. *Queen Tomyris Receives the Messenger Who Brings from Cyrus a Proposal of Marriage* (I:202–206) [East Wall, extreme South end]

V. *Queen Tomyris Learns That Her Son Spargapises Has Been Taken Captive by Cyrus* (I:211–213) [East Wall, middle]

The narrative sequence for the *Abraham Series* is:

I. *Abimelech Restoring Sarah to Abraham* (Gen. 20:1–16) [North-west corner of the room, right of the single Court window]

II. *Abraham Dismisses Hagar and Ishmael* (Gen. 21:5–18) [West Wall, left of the four Court windows]

III. *Rebecca Gives Water to Abraham's Servant* (Gen. 24:3–28) [West Wall, right of the Court windows]

IV. *Abraham's Servant Presenting Jewels and Raiment to Rebecca* (Gen. 24:49–59) [East Wall, left of the single window]

V. *Abraham Receives Rebecca* (Gen. 24:61–67) [North Wall]

EAST WALL (FROM LEFT TO RIGHT, HEADING TOWARD THE STAGE): bronze and brass **torchère** (probably Italian, 16th c.), one of six in the room. Gothic **credence** (French, ca. 1500). ON THE CREDENCE: **ewer** (*coquemar*) shaped like a bust (Flemish, late 15th c.). BESIDE THE CREDENCE: two walnut **armchairs** (Italian, early 19th c., in a revival of a Louis XV style), from a set of twelve in the room, and an iron **strongbox** (Dutch or Spanish, 16th c.).

TO THE RIGHT: **lectern** covered in velvet and bearing the arms of the Colonna family. The **armchair** is Italian, 17th century, and is one of five in the room (two others are by the Court, and two by the East Wall). ON THE WALL: brass **plate** (German, probably Nuremberg, 15th–17th c.), one of six in the room. The two on the East Wall depict grape bunches and Adam and Eve (both 17th c., acquired through Joseph Lindon Smith); another Adam and Eve (possibly 15th c.) is on the table by the

Saint Engracia, by Bartolomé Bermejo.

Detail of *Rebecca Gives Water to Abraham's Servant,* from the *Abraham Series* tapestries.

West Wall, and three above the triple Court window are Adam and Eve (left), stags (middle), and the Annunciation (right).

ON AN EASEL AT THE WINDOW: *Saint Engracia,* ca. 1475, by Bartolomé de Cárdenas, also called Bartolomé **Bermejo** (Spanish, active ca. 1468–1495), purchased from the De Somzée collection, Brussels, 1904, through Fernand Robert as an anonymous work. The central panel of an altarpiece is dedicated to Saint Engracia, possibly created for the church of San Francesco in Daroca. ON THE **DESK** (Italian, 17th c.) BELOW: pair of pewter candlesticks designed by Ignaz Marcel **Gaugengigl** (German-American, 1855–1932) (see Blue Room, p. 35), copied from a pair he made for the Tavern Club, Boston, in 1909. Gift of the artist, 1914. On the lower part of the desk is an 18th-century Italian **desk set** and some items that belonged to John L. Gardner. The straight **chair** is Venetian, 16th or 17th century.

ON THE OTHER SIDE OF THE EASEL: *Pope Innocent X* (1644–1655), a copy, possibly contemporary, **after** the large 1650 portrait by

Diego Velázquez (Spanish, 1599–1660), now in the Doria-Pamfili Gallery, Rome. Purchased from Prince Brancaccio, Rome, 1906, through Bernard Berenson as a work by Velázquez.

Continuing along the wall: **lectern**, covered with red velvet that is embroidered with the arms of Pope Clement XI (1667–1669); two stuffed **armchairs** (*pozetti*) (Italian, 19th c., Louis V revival style); between them is small **table** (Italian, 19th c.) supporting a large copper **dish** (Japanese, 19th c.); farther along is a carved walnut **writing cabinet** (Italian, style of the late 16th c.) supporting a hammered brass **flagon** (South German, 15th c.); the leather **armchair** is from a set of four—another is across the room and two are in the Gothic Room (p. 118).

The iron **pulpit** is perhaps Spanish or French (14th–15th c.); under it is a walnut **chest** (Spanish, 16th c.); above are a wrought-iron **bracket** (German, 17th c.) and a **lantern** matching the one across the room. Farther along is a tier of three oak **choir stalls** (French, 14th–15th c.). In front of the tapestry is a low **armchair** with Gobelin stitch embroidery (Italian, 19th c.).

The Gothic-arched stone **window** to the right and the two **windows** on either side of the fireplace on the South Wall are all probably Spanish, late 14th or early 15th century.

Flanking the fireplace: two iron **candelabra** (Flemish, late 15th c.). The French Gothic stone **fireplace** dates from the reign of François I (1515–1547), though it has since been partly restored. Hanging at either side of the fireplace: **tapestry fragments**, *Trumpeters* (left) and *Ladies Conversing with a Gentleman* (Flemish, probably Brussels, 1510–25). Above the fireplace: *Saint Michael*, after 1461, by Pere **García de Benabarre** (Spanish, active 1445–1483), purchased from Demotte, Paris, 1916, by Paul J. Sachs of Harvard, and from him during the same year. From a large altarpiece dedicated to Saint John the Baptist, it was originally in the Church of San Juan de Mercat in Lleida (now destroyed).

To the right is a large **chest** (North European, 17th c.); the **doorway** is partly modern, carved in the style of the French or Flemish Gothic period; over the door is a *Heraldic Panel of the Funeral Hatchment of Mary Queen of Scots*, 1915, by Pierre de Chaignon **La Rose** (American, 1871–date unknown).

TO THE RIGHT OF THE DOOR: *bargueño* (portable desk with small drawers behind a drop front) (Spanish, 17th c., on a 19th-c. stand), black painted walnut. The *F* and *Y* are for Ferdinand and Isabella, commemorating the union of the East and West kingdoms. ABOVE THE DESK: *La Gitana*, 1920, by Louis **Kronberg** (American, 1872–1965), purchased from the artist, 1921; HIGH ABOVE: large iron **bracket** (probably German, 17th c.) with lantern; at right is a small **table** (English, 17th c.).

ON THE EASEL: **icon**, *The Assumption of the Virgin* (Russian, probably Novgorod, 15th c.), gift of Thomas Whittemore, 1922. BELOW: silk cover or scarf, painted by Raymond **Duncan** (American, 1875–1966), brother of Isadora Duncan, gift of Louis Kronberg, 1921.

ON THE LONG TABLE: **plate** depicting Adam and Eve (see p. 76); carved wood **head of Christ** (South German, 15th c.); and **illuminated pages** from a mass book made for Pope Clement VII (1523–1534).

IN FRONT OF THE WINDOWS: oak Jacobean **dresser** (English, late 17th c.). ON THE DRESSER: silver gilt **cross** (Italian, 16th c.), gift of Stanley Lothrop, 1915; silver holy water **stoup** acquired in Madrid; a testimonial **book of autographs** presented to Gardner on her birthday in 1909, designed and bound by Mary Crease Sears; an Italian **box** painted in a Chinese style; a Persian **manuscript** of *The Divān of Hafīz*, dated 895 of the Hejira (ca. 1489–1490) and containing five miniatures.

BEYOND THE WINDOWS: long oak **table with drawers** (Spanish, 17th c.). ALONG THE TABLE, FRAMED IN PAIRS: six **miniatures**: *The Candle Clock*, a *Hydraulic Device*, and a *Water Clock*, all leaves

from the *Automata* of al-Jazarī (Egyptian, 1354); a *Medicinal Plant*, from an Arabic translation of Dioscurides's *De Materia Medica* (Mesopotamian, Baghdad, 1224); and *Kay Kaus Captured by the Divs* and *Rustam Fighting with Suhrab*, from the *Shahnameh* of Firdausi (Persian, mid-15th c.). In the last frame are two photographs of miniatures that are also from the *Automata* of al-Jazarī and are in the collection of the Museum of Fine Arts, Boston, and a paper-backed catalogue of these miniatures that was handwritten by Isabella Gardner. All of the miniatures were purchased from the Berlin Photographic Company, New York, 1914, through Bernard Berenson, except for the *Water Clock*, which was purchased from Leonce Rosenberg, Paris, 1914, through Denman Ross, and *Rustam Fighting with Suhrab*, which was a Christmas gift from Denman Ross in 1913.

ON THE PEDESTAL: polychromed wood **candelabrum** of the *Madonna della Misericordia* (Central Italian, 16th c.), perhaps from Arezzo.

TO THE RIGHT: upholstered **sofa** (English, 19th c.), covered with gros and petit point embroidery (French or Netherlandish, 1675–1725).

THROUGH THE CENTER OF THE ROOM: AT THE NORTH END: oval **table** (Italian, 17th c.), with the baluster legs characteristic of Bolognese work of that time. On it is a silver **lamp** (Venetian, 19th c.). AT THE SOUTH END: oak **draw table** (Dutch, 17th c.). The **armchair** (English, 17th c.) resides at the head of the table, the bequest of Mrs. James T. Fields, who purchased it on the recommendation of Charles Dickens as having belonged to Charles II. The embroidered **cushion** (Italian, 17th c.) on the seat was a gift of Edwin Sherrill Dodge, 1921. At the foot of the table is a "Dante" style **chair**. The other **chairs** are Louis XIII style (two more are near the embroidered sofa at the North end of the room). AMONG THE OBJECTS ON THE TABLE: Sheffield **candelabra**, a large majolica **platter**, and some Japanese **lacquerware**. *THE TABLE AND*

CHAIRS ARE PLACED TO THE SIDES OF THE STAGE DURING THE CONCERT SEASON AND MOVED BACK DURING THE SUMMER.

HIGH ABOVE, SUPPORTING THE CEILING BEAMS: six wooden **brackets** (Norman, 14th c. or earlier), carved in grotesque forms of human beings and animals. The two full-length wooden ecclesiastical **figures** may be English, 17th century.

➤ THROUGH THE GOTHIC–STYLE DOORWAY IN THE WEST WALL:

Second Floor Elevator Passage

ABOVE THE DOOR: *The Vinegar Tasters*, two-fold **screen** (Japanese, Kanō school, 17th c.), purchased from the Bunkio Matsuki sale, Boston, 1901, as a work by Kanō **Motonobu**. The screen depicts the legend in which Confucius, Sakyamuni and Lao-tzu each took a taste of vinegar. Confucius called it sour, Sakyamuni bitter, and Lao-tzu sweet. It is implied that their teachings (Confucianism, Buddhism, Taoism) head to the same truth, despite their different experiences.

AT THE RIGHT: *Chrysanthemums and Bamboo*, set of four *fusuma* (sliding doors) (Japanese, Kanō school, 17th c.) painted on gold ground, purchased from Joseph Lindon Smith, 1911. Three others of the set are on the opposite wall.

Two-fold Japanese screen depicting *The Vinegar Tasters*, Kanō school, 17th century.

BELOW: chain-stitch embroidery **bedcover** (Bengal, 1600–1650), probably made for the Portuguese market. ABOVE AND TO THE RIGHT: **balcony railing** (Italian, 17th century).

OPPOSITE WALL: *Rice Cultivation*, two six-fold **screens** (Japanese, Kanō school, 17th c.). Acquired by 1912, their provenance is not known.

The elevator shaft is enclosed in panels from late 18th-century Japanese **shrine doors** (west side), supposedly from the Raikoji Temple at Nara, purchased at the Yamanaka sale, Boston, 1902; and Chinese red-lacquered wooden **doors** (south side), purchased in China by Joseph Lindon Smith, 1909/10.

ON THE DOOR TO THE DUTCH ROOM: large bronze knocker of *Neptune with Two Sea Horses*, **copy after Alessandro Vittoria** (Venetian, 1525–1608). BELOW IT: panel of **embroidery** with appliqué work (Italian, 1525–1550), part of an orphrey.

➤THROUGH THE DOOR:

Dutch Room

OVER THE DOOR: large needlepoint **embroidery** (French or English, 1590–1610) of *A Man and a Woman in a Garden*, purchased from Antonio Carrer, Venice, 1893, through Ralph Curtis.

FLANKING THE DOORWAY: *Sir William Butts, M.D.*, and *Lady Butts*, ca. 1543, two portraits by Hans **Holbein the Younger** (German, 1497/8–1543), purchased from Colnaghi, London, 1899, through Bernard Berenson. Holbein became court painter to Henry VIII in 1536. William Butts, who died in 1545, was a scholar as well as court physician. BELOW, RIGHT: *Lady Butts*, stipple engraving, reproducing Holbein's drawing for this picture in Windsor Castle.

TO THE LEFT OF THE DOORWAY: one of a set of six Empire **chairs** (French, 19th c.), with figured damask. IN THE CORNER: French

The Southeast corner of the Dutch Room, looking toward *Queen Mary of England,* from the studio of Anthonis Mor.

walnut ***panetière*** ("bread cooler") (Arles, 18th c.), gift of Dodge Macknight, 1907.

ON THE WALL TO THE LEFT: *Portrait of a Lady in Black and White,* by Alessandro **Allori** (Florentine, 1535–1607), purchased in London, 1898, through Berenson as a work by Bronzino. HIGH ABOVE THE WINDOWS: front of a **cassone** with two portraits and the Orsini coat of arms (Italian, 15th c.), purchased from Attilio Simonetti, Rome, 1897, through Joseph Lindon Smith.

BETWEEN THE COURT WINDOWS: high-backed **bench** (Florentine, early 16th c.), walnut with inlay and partly restored. ABOVE THE BENCH: *A Lady with a Rose,* by Anthony **Van Dyck** (Flemish, 1599–1641), purchased from Colnaghi, London, 1897, through Berenson.

CONTINUING TO THE LEFT: *A Man in a Fur Coat,* 1521, by Albrecht **Dürer** (German, 1471–1528), purchased from Colnaghi, London, 1902, through Berenson.

The Dutch Room, looking toward the Stair Hall, with Rembrandt's *Self-Portrait* to the right of the doorway.

TO THE LEFT: *Self-Portrait,* 1629, by **Rembrandt** Harmensz. van Rijn (Dutch, 1606–1669), purchased from Colnaghi, London, 1896, through Berenson. This was the first important purchase by Isabella Gardner for the stated purpose of creating a public museum. BELOW: the carved oak **cabinet** is modern, in a 17th-century Dutch style. ON THE SIDE OF THE CABINET, FRAMED: *Portrait of the Artist as a Young Man,* ca. 1633, etching (state II), by **Rembrandt**, purchased from the Mary J. Morgan collection, New York, 1886. *THIS PRINT WAS STOLEN FROM THE MUSEUM ON MARCH 18, 1990.* ON EITHER SIDE OF THE CABINET: two **chairs** (probably Italian, in the style of Louis XIV) are from a set of fourteen in the room.

OVER THE DOORWAY: painted wood **statue** (Bavarian, ca. 1520) in three-quarter relief of *Saint Martin and the Beggar,* purchased from the Émile Peyre collection, Paris, 1897.

AT THE LEFT: *Portrait of Isabella Clara Eugenia, Archduchess of Austria,* ca. 1598–1600, by Frans **Pourbus II** (Flemish, 1569–1622), purchased from Durand-Ruel, New York, 1897. BELOW: ivory-inlay **chest** (Venetian, early 19th c., in the style of Louis XV), decorated in marquetry of burl walnut with satinwood borders.

The Concert,
by Jan Vermeer.

IN THE CORNERS (on black wooden columns with gilded capitals): four bronze **candelabra** (French, early 19th c.).

ON AN EASEL BY THE WINDOWS: *The Concert,* ca. 1658–60, by Jan **Vermeer** (Dutch, 1632–1675), purchased at the Thoré-Burger sale in Paris, 1892. *THIS PAINTING WAS STOLEN FROM THE MUSEUM ON MARCH 18, 1990.* In front of it in the glass case are miscellaneous **desk supplies** and implements for burning incense. The silver lion-shaped **inkstand** was made in London (1849–50) by Charles T. and George Fox. It was given to Sir George Bowles by Queen Victoria. ON THE OPPOSITE SIDE OF THE EASEL: *The Obelisk,* 1638, by Govaert **Flinck** (Dutch, 1615/16–1660). Thought to be by Rembrandt for over a century (his monogram was forged over Flinck's), it was purchased from Colnaghi, London, 1900, through Berenson. *THIS PAINTING WAS STOLEN FROM THE MUSEUM ON MARCH 18, 1990.* IN FRONT OF IT ON THE TABLE: two rare Chinese **tomb figurines**: a serpentine pig (Warring States period, ca. 3rd c. B.C.), gift of Denman Ross, 1922; and an earthenware dog with an iridescent green glaze (Han dynasty, 206 B.C.–220 A.D.), purchased from Parish-Watson, New York, 1922, through Denman Ross.

BY THE FAR WINDOW: *The Virgin and Child in a Rose Arbor,* **after Martin Schongauer** (German, ca. 1450–1491), purchased from

Colnaghi, London, 1899, through Berenson, as a work by Schongauer. An early 16th-century copy, in reduced size, of a large painting in Saint Martin's church at Colmar, Alsace.

ON TOP OF THE CABINET: a terra-cotta bust of *Saint John the Baptist*, ca. 1480, from the **workshop of Benedetto da Maiano** (Florentine, 1442–1497), purchased from Julius Böhler, Munich, 1897, as a work by Donatello. INSIDE THE CABINET: TOP SHELF: silver gilt **tankard**, made in Danzig, 17th c.; two silver **goblets** (Paris, 18th c.). SECOND SHELF: silver **ostrich** mounted around an ostrich egg (German, 17th c.); small silver teapot by Thomas **Whipham** and Charles **Wright** (London, 1768–1827); two-handled cup by Richard **Bayley** (London, 1749). BOTTOM SHELF: silver tureen and tray made by Charles **Odiot** (Paris, 19th c.); silver **candlestick** (London, 1648–49); silver tankard by Hans Pettersen **Blytt** (Bergen, ca. 1740); *art nouveau* silver soapbox, 1895–97, by Christian **Eriksson** (Swedish, 1858–1935), made for Gardner at the recommendation of Anders Zorn.

FOLLOWING THE SOUTH WALL, RIGHT TO LEFT: *A Doctor of Law at the University of Salamanca*, ca. 1635, by Francisco de **Zurbarán** (Spanish, 1598–1664), purchased from the Ehrich Galleries, New York, 1910. ON THE TABLE BELOW: bronze *Ku* (beaker) (Chinese, Shang dynasty, 1200–1100 B.C.), purchased from Parish-Watson, New York, 1922, through Denman Ross. *THIS OBJECT WAS STOLEN FROM THE MUSEUM ON MARCH 18, 1990.* The *Storm on the Sea of Galilee*, 1633, by **Rembrandt**, purchased from Colnaghi, London, 1898, through Berenson. It is his only known seascape. *THIS PAINTING WAS STOLEN FROM THE MUSEUM ON MARCH 18, 1990.*

The oak **cabinet** is a 19th-century copy of a North German 17th-century style. ON THE CABINET: *Portrait of the Dauphin François* (1517–1536), **after a lost portrait by Corneille de Lyon** (French-Dutch, 16th c.), purchased from the Bonomi-Cereda collection, Milan, 1895, through Berenson, as a work by Clouet. ABOVE THE CABINET: *The Madonna and Child*, by an **unknown**

painter, influenced by Rogier van der Weyden (Netherlandish, ca. 1400–1464), purchased in Paris, 1895, through Fernand Robert, as a work by Lucas van Leyden.

To the left: *Thomas Howard, Earl of Arundel*, 1629, by Peter Paul **Rubens** (Flemish, 1577–1640), purchased from Colnaghi, London, 1898, through Berenson. *Anna van Bergen, Marquise of Veere* (1492–1541), **after Jan Gossaert van Maubeuge, called Mabuse** (Flemish, ca. 1478–1532), purchased from the Bonomi-Cereda collection, Milan, 1895, through Berenson, as a work by Jan Scorel. Below: high-back carved oak **throne** (Auvergne, 16th c.). The back and seat are a modern restoration.

To the left: *A Lady and Gentleman in Black,* 1633, by **Rembrandt**, purchased from Colnaghi, London, 1898, through Berenson. *This painting was stolen from the Museum on March 18, 1990.*

The carved walnut **cabinet** is Italian, late 16th century. On the cabinet: stoneware **jug**, *Grenzhausen* ware or "Graybeard" jug (German, 18th c.), bearing the arms of Amsterdam. The jug was found while excavating the cellar of the Old Brattle Street Church, Boston (now destroyed). The church was used by Hessian and British soldiers as a barrack in 1775.

To the left: *A Young Commander*, by Justus **Suttermans** (Flemish, 1597–1681). The sitter is now identified as Alfonso d'Este, but the portrait was acquired from Vincenzo Favenza, Venice, 1892, as the Duke of Monmouth.

On the East Wall in the corner: *A Lesson on the Theorbo*, by Gerard **ter Borch** (Dutch, 1617–1681), purchased from Colnaghi, London, through Bernard Berenson, 1898.

To the left: *Queen Mary of England*, from the **studio of Anthonis Mor** (Dutch, ca. 1519–1577), purchased from Dowdeswell and Dowdeswell, London, 1901, through Berenson. The original portrait is in the Prado. Below: upholstered walnut **sofa** with gros and petit point embroidery (French or Flemish, 1650–1725).

To the right of the fireplace: *The Annunciation*, drawing, **copy after a lost original by Rembrandt**. Formerly in the collection of Sir Joshua Reynolds. Below the drawing is a small **commode** (Italian, possibly Venetian, ca. 1750) with walnut veneers and ivory inlays.

The red marble **fireplace** is 16th-century Italian. On the hood: marble inscribed **panel** (Venetian, dated 1497). On the mantel: two stone **angels** with candlesticks. The one on the left is Italian, 15th century, and is close to the work of Domenico **Rosselli** (Florentine, ca. 1439–1497/98).

On either side of the fireplace: two **wood carvings** (North Italian or South German, 16th c.), apparently cut down, representing the Nativity and the Resurrection.

To the left: *Three Captives*, colored pencil sketch, by **Rubens**, after Mantegna's *Triumph of Caesar.* Below: oak **chest** (North German, provincial, 17th c.) with carved top. To the left: Dutch **linen press,** modern, in the style of the 17th century in Holland.

In the middle of the room: large **refectory table** (Tuscan, with the date 1599 on the stretcher). The other **table** is also Italian, 16th century.

The painted **ceiling**, perhaps from a public building, is from Orvieto, ca. 1500, with the arms of several Roman families. It was purchased in Rome, 1897, through Richard Norton. The **tiles** comprising the floor and inside the fireplace are by Henry Chapman **Mercer** (American, 1856–1930) (see pp. 41 and 51).

➤ through the doorway,
 passing Rembrandt's *Self-Portrait*:

Second Floor Stair Hall, South

The carved stone **doorway**, surmounted by the arms of the Doge, Andrea Gritti, is Venetian, ca. 1500.

BETWEEN THE COURT WINDOWS: **tapestry**, *Messenger Delivering a Letter* (Flemish or French, 1675–1700), purchased in Paris. ABOVE: *The Battle of the River Uji*, eight-fold **screen** (Japanese, late 17th c.), purchased from the Bunkio Matsuki sale, Boston, 1902, as a work by Tosa Mitsunobu. BETWEEN THE WINDOW AND THE DUTCH ROOM: **tapestry**, *Construction of the Tower of Babel* (Flemish, Brussels, 1590–1620, probably woven by Martin Reymbouts).

IN THE CORNER, LEFT TO RIGHT: two **tapestries**, *Spring* (Flemish, Brussels, 1535–50, probably woven by Andreas Mattens) and *The Warrior's Consultation* (Flemish, probably Brussels, 1575–1625). IN FRONT: octagonal **table** (Florentine, 18th c.), with pedestal legs in the form of sphinxes. The **chairs** are American in the style of Duncan Phyfe, early 19th century.

ON THE WALL, AT THE FIRST STAIR LANDING: section of the lid (?) of a sarcophagus (Roman, ca. 300). BELOW: marble relief **escutcheon** (Italian, 16th c.), with the arms of Andrea Valle, Bishop of Cotrone (1496–1508).

OPPOSITE, OVER THE COURT WINDOWS: *The Musicians*, ca. 1543, Neapolitan fresco fragment, by **Giorgio Vasari** (Florentine, 1511–1574) **and studio**, purchased from Vincenzo Barone, Naples, 1897.

The Musicians, by Giorgio Vasari and studio.

Third Floor Stair Hall, North

ON THE WEST WALL, LEFT TO RIGHT: **tapestries**: *Amazons Preparing for a Joust* (Flemish, probably Tournai, ca. 1450–75), purchased from the Émile Peyre collection, Paris, 1897; and *Esther Fainting before Ahasuerus* (Flemish, Brussels, 1510–25), acquired in Paris, 1897. The **bench** below it is Italian, made from a late Renaissance cassone.

FLANKING THE DOORWAY: pair of gilded wood **chancel candle-sticks** (Italian, 16th or 17th c.), purchased from Giuseppe Pacini, Florence, 1903, through Joseph Lindon Smith. ABOVE THE DOORWAY: iron **bracket** and **pulley** (probably Sienese, 16th–17th c.). TO THE RIGHT ON THE EAST WALL: *Portrait of a Lady in Black*, late 1590s, by Domenico **Tintoretto** (Venetian, ca. 1560–1635), purchased from Knoedler & Co., New York, 1903, on the recommendation of John Singer Sargent as a work by Jacopo Tintoretto. BELOW: walnut-veneered pine **cupboard** (Italian, 17th c.). ON THE CUPBOARD: *Bust of a Roman,* bronze, **attributed to Simone Bianco** (Venetian, 16th c.), purchased from Gimpel & Wildenstein, New York, 1910, through Berenson, as a 15th-century portrait of Alamano Rinuccini.

The Third Floor Stair Hall, Northeast corner, with Domenico Tintoretto's *Portrait of a Lady in Black.*

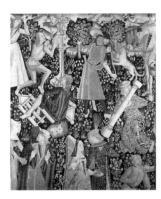

Proverbs tapestry,
Flemish,
1475–1500.

To the right, beyond the window: **tapestry**, *The Fulfillment of the Curse on Ahab* (Flemish, Tournai or Arras, ca. 1460–70), purchased from Bachereau, Paris, 1897. The subject is taken from the Book of Kings (I Kings 21; II Kings 9, 10). Beyond the triple window: painted wood **statue** of the *Angel of the Annunciation* (Sienese, late 14th c.), purchased from Stefano Bardini, Florence, 1899. The companion piece, *The Annunciate Virgin*, is in the Musée Jacquemart-André, Paris.

Opposite:

Tapestry: *Proverbs* (Flemish, 1475–1500), purchased from Seligman, Paris, 1905, through Joseph Lindon Smith. The recognizable proverbs are:

I. A man who "eats wheat in the raw"—is spending his wealth (harvest) before he earns (reaps) it.

II. A man who "holds two candles to the devil"—countenances wrongdoing, or possibly hypocrisy.

III. One who "bells the cat"—performs a heroic deed, or dares.

IV. The figure holding a flame in one hand and a bucket of water in the other "blows hot and cold"—speaking good and evil of the same thing.

V. The man who "falls between two stools"—cannot make up his mind.

VI. The man who "bites the pillar"—is a hypocritical churchgoer.

VII. The woman putting the blue cloak on the man—cuckolds her husband.

VIII. The woman holding the purse of the man trying to embrace her—marries him for his money.

IX. This last figure is incomplete and has not been deciphered.

No other tapestries of this type are known to have survived.

DIVIDING THE HALLWAY: iron **grill** and **grate** (Italian, 15th c.).

➤ TURNING BACK AND PASSING BETWEEN THE CANDLESTICKS:

Veronese Room

The carved, gilded, and painted **ceiling** in Early Renaissance style, made in Milan for the museum in 1901, provides a setting for *The Coronation of Hebe*, ca. 1580s, by Paolo Caliari, called **Veronese** (Venetian, 1528–1588), his son Gabriele **Caliari** (Venetian, 1568–1631), **and workshop**. This was painted for a ceiling in the della Torre palace at Udine and was purchased from Boudariat, Paris, 1899, through Fernand Robert as a work by Veronese.

Tooled and gilded leather **panels** cover the walls of the room. They were largely acquired in France and Venice during the 1890s. Above the rail, North, West, and South Walls: Netherlandish, early 18th century. Surrounding the fireplace: Spanish or Italian, early 18th century. The larger altar panels are French or Italian, 17th and 18th century.

TO THE RIGHT OF THE DOOR: walnut **armchair** (Italian, early 17th c.), with tooled-leather back and seat, one of a set of six in the room.

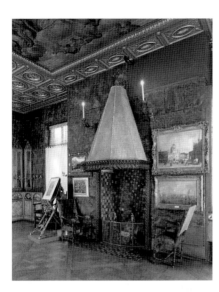

The Veronese Room.

On the South Wall: large **mirror** (Venetian, 1750–1800), engraved with figures of heroes of antiquity. Below the mirror: **commode** (Venetian, 18th c. or later, in the style of Louis XVI). On the commode: **toilet mirror** (Venetian, Louis XV period, 1710–1774), and two majolica *albarelli* (apothecary jars) (18th c.).

On the East Wall, by the Court window: *With His Mamma*, 1888, by Anders **Zorn** (Swedish, 1860–1920), acquired prior to 1903, presumably from the artist. Below: **armchair** (Venetian, mid-18th c., in the style of Louis XV). Another stands in front of the table in the northeast corner. To the left: painted **tip-top table** (Italian, mid-18th c.). The oval top shows Diana seated in the clouds, with Apollo and Cupid.

Out in this corner of the room: **sedan chair**, a composite of 17th- to 19th-century work, with painted garden scenes. Both

the door inscription and the coat of arms on the back are spurious. Acquired in Boston in 1892.

To THE LEFT OF THE DOORWAY: **sofa** (probably Venetian, 19th c., in the style of Louis XVI).

On THE WALL: *The Wedding of Frederick Barbarossa to Beatrice of Burgundy*, ca. 1752, by Giovanni Domenico **Tiepolo** (Venetian, 1727–1804), purchased in Paris, 1900, through Fernand Robert, on the advice of Ralph Curtis, as a work by Giovanni Battista Tiepolo. This is related to the fresco painted by Giovanni Battista Tiepolo in the Kaisersaal of the Residenz of the Prince Bishop of Würzburg.

BELOW IT, LEFT TO RIGHT: four works by James A. McNeill **Whistler** (American, 1834–1903), all acquired from the artist: *The Little Note in Yellow and Gold*, 1886, pastel on cardboard, this is a portrait of Isabella Gardner; *The Violet Note*, ca. 1885/86, pastel on cardboard; *Lapis Lazuli,* ca. 1885/86, pastel on cardboard; and *The Note in Orange and Blue (Sweet Shop)*, ca. 1884, oil on wood. All are in their original frames.

The gilt porcelain tea service on the Veronese Room table, looking toward the Northeast corner. Four works by Whistler are among those on the far wall.

IN THE CORNER: **writing desk** (probably German, 19th c.) of satinwood veneer, in the Adam style of the 18th century. The back of the desk is a pierced screen of scroll- and latticework with shaped and printed panels. In front of it is a **gig seat** (Venetian, 18th c.), painted in *vernis Martin*, a reddish-brown varnish used in imitation of Chinese lacquer. ABOVE THE DESK: *The Vision of Saint Anthony of Padua*, probably after 1662, oil on copper, by Filippo **Lauri** (Roman, 1623–1694). The frame is Italian, 17th century. The objects on the desk are largely souvenirs from Gardner's travels.

OUT IN THE ROOM, ON THE TABLE: gilt porcelain **coffee and tea service** (probably French, ca. 1810–20; see the Yellow Room, p. 19, for the coffeepot from this set); and Meissen **plates** (Dresden, 19th c.).

BETWEEN THE WINDOWS: marble-topped **console table** (Venetian, late 17th c.). IN THE VITRINE (Venetian, 18th c.): black glass **Madonna** (Murano, ca. 1600), purchased from M. Guggenheim, Venice, 1897. "Black Madonnas" possibly originated as reproductions of old and venerated Byzantine and Romanesque altar-figures that had become blackened by candle smoke. Green glass **candlesticks** (Venetian, ca. 1700), mounted in gilt bronze. The *albarelli* are majolica, dated 1701. TO THE LEFT AND RIGHT: gilt bronze **candelabra** (French, 19th c.). Suspended from one of them is an **ostrich egg**.

ON THE WALL: *Portrait of a Member of the Contrarini Family* (Alvise Contrarini?), after 1703, by Pietro **Uberti** (Venetian, 1671–1762), gift of Charles Eliot Norton, 1902.

IN THE GILT VERTICAL CABINETS IN THE CORNER: a variety of **laces**, mainly of Italian origin. The display, selected from Gardner's extensive collection of laces, is rotated the same as the textiles in the Short Gallery (see p. 64).

TO THE RIGHT OF THE FIREPLACE: ABOVE: *The Torre dell'Orlogio, Venice*, late 18th–early 19th c., by a **follower of Francesco**

Guardi (Venetian, 1712–1793), purchased at the Charles Stein sale, Venice, 1899, on the recommendation of Ralph Curtis as a work by Guardi. BELOW: *View of the Riva degli Schiavoni and the Piazzetta from the Bacino di San Marco*, ca. 1760s, by **Guardi**, purchased from Colnaghi, London, 1896, through Berenson.

IN FRONT: two **armchairs** (Italian, probably Lombard, mid-17th c.).

AT THE LEFT: ABOVE: *The Story of David and Bathsheba*, by **Herri met de Bles** (Netherlandish, active 1535–1575), purchased from Galleria Sangiorgi, Rome, 1895. Scenes from the Old Testament story are illustrated, but they are secondary to the artist's interest in the outdoor pastimes of castle life in the 16th century: tennis, a jester, falconry, bathing, archery, a maze, and stag hunting. BELOW: *The Birth of Caterina Cornaro (?)*, by an **unknown provincial artist** (probably Austrian, 1550–1600), purchased from the Galleria Sangiorgi, Rome, 1895.

LEFT: carved and gilded **lectern** (Italian, late 18th c.). ON THE LECTERN: *The Mystical Marriage of Saint Catherine*, ink and gouache drawing, from the **studio of Veronese**, purchased from the Robinson sale, Agnew & Sons, London, 1902.

CATTY-CORNER TO THE FIREPLACE: three painted **trays** (probably Venetian, 18th c.), over a triangular **cabinet** (probably English, 19th c.).

IN THE CORNER BY THE DOOR: three **fans** (French, 18th c.) and three **miniatures**, in a Louis XVI style **case**, made for Gardner by Millot, Paris, 1892.

The Titian Room, looking toward Titian's *Europa.*

➤ THROUGH THE DOORWAY IN THE EAST WALL:

Titian Room

TO THE LEFT, ON THE WEST WALL: *The Child Jesus Disputing in the Temple,* ca. 1545, by Paris **Bordone** (Venetian, 1500–1571), purchased from J. P. Richter, 1901, through Berenson. BELOW: **settee** (English, 18th–19th c.), painted black with caned seat and back. ON EITHER SIDE OF THE SETTEE: pair of **armchairs** (Italian, 18th c.) from a set of four in the room.

AT THE RIGHT, BY THE WINDOW: *Portrait of Juana of Austria and a Young Girl,* ca. 1561/62, by **Sofonisba Anguissola** (Cremonese, ca. 1535–1625), painted during her tenure at the Spanish Court. Purchased from the Marquis Fabrizio Paulucci de'Calboli, Forlì, Italy, 1898, through Berenson as a work by Titian. Berenson later attributed it to Sanchez Coello or Pantoja de la Cruz.

BETWEEN THE WINDOWS TO THE RIGHT: *The Continence of Scipio,* late 1540s or early 1550s, from the **studio of Bonifazio di Pitati, called Bonifazio Veronese** (Venetian, 1487–1553), purchased from Consiglio Ricchetti, Venice, 1897, as works by Bonifazio. The story is from Livy, *History of Rome* (Books 26–50). This painting is probably a pendant to *The Story*

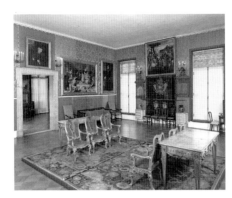

The Titian Room, looking Northwest, toward the *Portrait of Juana of Austria and a Young Girl,* by Sofonisba Anguissola.

of Antiochus and Stratonica on the opposite wall. Below: red velvet **hanging** (Italian, 1738–75) bearing the shield of a marquis. Across the velvet: **glaive**, said to have been borne by the palace guard of Pope Paul V (1605–1621) (Camillo Borghese, 1552–1621), but more likely commissioned by one of his nephews, Cardinal Scipione Borghese-Caffarelli (1576–1633).

Above, on either side: two **frames** (Italian, late 15th c.). In the right one is a velvet furnishing or garment **fabric** (Persian, 1550–1600). Below: two small **cabinets** (Italian, late 18th c., in the style of Louis XVI). On the cabinets: two glass **vases** (Venetian, 19th c.). Between the cabinets: two marble inlaid high-back **side chairs** (Venetian, 19th c.), in the English Jacobean style; and two mahogany **side chairs** (Italian, early 19th c.), of a set of six in the room.

By the middle window, on an easel: *Christ Carrying the Cross,* ca. 1505–10, from the **circle or studio of Giovanni Bellini** (Venetian, ca. 1430–1516), purchased from Count Zileri dal Verme, Vicenza, 1898, through Berenson as a work by Giorgione. Few scholars still support that attribution.

In the cabinet to the right: collection of **decanters**, drinking **glasses**, **vases**, and glass **boxes**. The large glass *tazza* with a

swan in the center and the large footed **bowl** decorated with red, white, and blue dots are both Venetian, ca. 1525. Those etched with a coat of arms (castles and eagles) form a set (Dutch or Spanish, 17th c.). Another group of seventeen **tumblers** and five **decanters** is mostly German, 18th century; two of the tumblers and one of the decanters are *zwischengoldglass* (gold between layers of glass) and are Italian, late 18th century, and of a set with the one in the Raphael Room (see p. 64). Seven gilded **wine glasses** with a cardinal's arms are Saxon or Bavarian, 17th century. The two lavender cameo vases are by Emile **Gallé** (French, 1846–1904). The spherical green-glass **jug** with a bronze loop handle is ancient, possible Graeco-Roman, 1st or 2nd century.

ON THE CABINET: marble **bust** (Venetian, 18th c.) of a Venetian senator, purchased from Consiglio Ricchetti, Venice, 1897. BEHIND ON THE WALL: a **velvet hanging** with an embroidered insignia (Italian, 1700–1775).

ON THE EAST WALL: *Europa,* 1559–62, by Tiziano Vecellio, called **Titian** (Venetian, ca. 1488–1576), purchased from the Earl of Darnley, 1896, through Berenson. Painted for Philip II of Spain, the story comes from Ovid's *Metamorphoses* and depicts the Phoenician princess, Europa, being carried off by the god, Jupiter, disguised as a bull. ON THE WALL BELOW: silk **garment fabric** (French, Lyons, 1885–95) cut from a gown designed by Frederick Worth and worn by Isabella Gardner.

BELOW: two **console tables** (perhaps Roman, mid-18th c.). ON THE LEFT TABLE: silver **chalice**, elaborately combining Renaissance, Mannerist, and Baroque styles (Italian, late 19th c.), purchased through Richard Norton, Rome, 1900, allegedly coming from the Vatican as an unknown work by Benvenuto Cellini; angel **candleholders** (one on each table) (Roman, first quarter of the 17th c.), purchased from Consiglio Ricchetti, Venice, 1890; *Cupid Blowing a Horn,* bronze, **attributed to François Duquesnoy, called Il Fiammingo** (Flemish,

1597–1643); enameled copper **plate** (Venetian, 16th c.). ON THE RIGHT TABLE: *The Rape of Europa*, sketch in pencil and watercolor, **attributed to Anthony Van Dyck** (Flemish, 1599–1641), after Titian; *The Rape of Europa*, 1917, small bronze plaque, by Paul **Manship** (American, 1885–1966), gift of the artist, Christmas 1917.

OVER THE DOORWAY: *Christ Delivering the Keys of Heaven to Saint Peter*, ca. 1521–25, by Vincenzo **Catena** (Venetian, active 1500–1531), purchased from J. P. Richter, London, 1895, through Berenson. The three witnesses are Faith, Hope, and Charity.

RIGHT: *King Philip IV of Spain*, ca. 1626–28, by Diego **Velázquez** (Spanish, 1599–1660), purchased from Colnaghi, London, 1896, through Berenson.

ON THE COLUMN: *Bindo Altoviti*, 1550, by Benvenuto **Cellini** (Florentine, 1500–1571), purchased from Colnaghi, London, 1898, through Berenson. Altoviti (1490–1556) was a Florentine banker and patron of the arts. BEHIND THE COLUMN: **cope** (Italian, 16th c.).

IN THE CORNER: *Self-Portrait*, ca. 1550, by Baccio **Bandinelli** (Florentine, 1493–1560), purchased from Colnaghi, London, 1898, through Berenson, as a portrait of Michelangelo by Sebastiano del Piombo.

ON A HINGE BY THE WINDOW: *A Girl with a Lute*, 1520, by **Bartolommeo Veneto** (Cremonese-Venetian, active 1502–1546), purchased through Richard Norton, Rome, 1900.

BETWEEN THE WINDOWS: ABOVE: *The Story of Antiochus and Stratonica*, from the **studio of Bonifazio Veronese** (see its pendant on the opposite wall, p. 97). BELOW: red velvet **hanging** (Italian, 18th c.), probably part of a dossal or a canopy for a throne. The badge representing a dog with a flaming tongue is a Dominican one. BELOW THE HANGING: fabric-covered **chest** (Italian, 18th c.) for storing laces and silks. The covering material is velvet brocade (possibly Persian, 17th c. or later).

ON A HINGE IN THE WINDOW TO THE RIGHT: *The Nativity,* an early work by **Liberale da Verona** (Veronese, ca. 1443–1526), purchased from Antonio Carrer, Venice, 1897, without an attribution to an artist.

BY THE DOUBLE COURT WINDOW: six leather-covered walnut **chairs** (Italian, 18th c.).

ON THE WEST WALL, IN THE CORNER: *Full-Length Portrait of a Bearded Man in Black,* 1576, by Giovanni Battista **Moroni** (Bergamask, early 1520s–1578), purchased from the Galleria Sangiorgi, Rome, 1895.

ON THE WALL UNDER GLASS: **cope** and **hood** (Italian, 1675–1750). IN THE CENTER: **commode** (Venetian, 18th c.), purchased from Moisè dalla Torre & Co., Venice, 1906. ON THE COMMODE: Namban **chest** (Japanese, middle of the 17th c.). ABOVE THE COMMODE: *Venus Wounded by a Rose's Thorn,* by an **unknown painter** (Italian, probably first half of the 16th century), purchased from either A. Massori, Rome, or Gagliardi, Florence, 1897, through Berenson, as a work by Correggio. A copy after the engraving by Marco Dente da Ravenna, which was derived from the decoration of the Stufetta of Cardinal Bibbiena by the studio of Raphael.

TO THE RIGHT, ABOVE: *Portrait of a Lady in a Turban,* ca. 1516–18, by Francesco **Torbido** (Venetian, 1482/83–1562), purchased from Colnaghi, London, 1896, through Berenson, as a portrait of Isabella d'Este by Polidoro Lanzani.

BELOW: *Madonna and Child in a Landscape with Saint Joseph, the Infant Saint John the Baptist, and Saint Elizabeth,* ca. 1520–25, by **Bonifazio Veronese**, purchased from J. P. Richter, London, 1895, through Berenson.

OVER THE DOOR: *Portrait of Zaccaria Vendramin,* 16th c. or later, by a **follower of Tintoretto**, possibly a copy after a lost original, purchased in 1896, through Berenson, as a work by Tintoretto.

IN THE CENTER OF THE ROOM: **carpet** (Persian or Indian, 17th c.), called the *Isfahan* type. Purchased from Benguiat Brothers, London, 1894, through John Singer Sargent. ON THE CARPET: gilded **armchairs** (Italian, 18th c.) with cane seats and backs, a set of seven in the room. Generally in the style of Louis XIV, the top and center splat is Queen Anne, purchased from the Borghese sale, Rome, 1892, through Ralph Curtis; and two **console tables** (Italian, 19th c.), with marble tops from Siena.

➤ THROUGH THE DOORWAY IN THE EAST WALL:

Long Gallery

The Long Gallery divides into three sections. The Northern and Middle sections are separated by the Moorish archway; the third section, at the South end, is the Chapel.

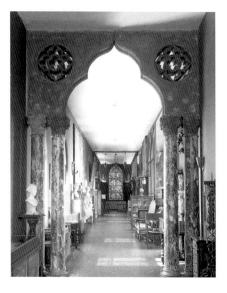

The Long Gallery, looking South.

Long Gallery, Northern Section

LEFT: walnut **armchair** (Spanish, 16th–17th c.), one of four unmatched but similar chairs in the gallery. ABOVE IT: glazed polychromed terra-cotta tabernacle front from the **workshop of Andrea della Robbia** (Florentine, 1435–1525), purchased from the Émile Peyre collection, Paris, 1897, through Fernand Robert, as a work by Andrea della Robbia.

ALONG THE WALL: large **sideboard** (Florentine, late 15th c.). ON THE SIDEBOARD, LEFT TO RIGHT: marble **bust** of Raffaello Riario, Cardinal Sansoni (Roman, early 16th c.), purchased from Dowdeswell and Dowdeswell, London, 1907, through Berenson, as a work by Andrea Verrocchio; **helmet** (North Indian, 17th or 18th c.); **fragment of a mosque lamp** (Syrian or Egyptian, mid-14th c.); brass **bowl** (Syro-Egyptian, mid-14th c. or later); marble portrait **relief** of *Petrus Bon* (Venetian, late 15th c.), purchased in Rome, 1901, through Richard Norton, as a work by Pietro Lombardo.

ON THE WALL ABOVE: *Madonna and Child with an Angel,* ca. 1472–75, by Alessandro Filipepi, called Sandro **Botticelli** (Florentine, 1445–1510), purchased from Colnaghi, London, 1899, through Berenson. Also known as the "Madonna of the Eucharist" or the "Chigi Madonna."

A Roman 16th-century bust of Raffaello Riario and Botticelli's *Madonna and Child with an Angel.*

IN THE CORNER BY THE WINDOW: marble relief of a woman, ca. 1475–80, by **Mino da Fiesole** (Florentine, 1429–1484). From the Palazzo Antinori-Aldobrandini; purchased from Volpi, Florence, 1899, through Berenson. BELOW THE RELIEF: brass **plate** (Venetian, 16th c.), inlaid with silver and etched. IN THE CORNER, TO THE RIGHT OF THE WINDOW: painted terra-cotta *Virgin Adoring the Child*, ca. 1480, by Matteo **Civitali** (Lucchese, 1436–1501), purchased from Attilio Simonetti, Rome, 1902, through Joseph Lindon Smith. ON THE FLOOR IN FRONT OF IT: bronze **basin** (Japanese, mid-19th c.), for incense.

TO THE RIGHT, ON THE WALL: *The Nativity*, ca. 1482–85, tondo, by **Botticelli**, purchased from the collection of the Duke of Brindisi, Palazzo Antinori, Florence, 1900, probably through Richard Norton. BELOW THE TONDO: **bench** (Italian, 17th–18th c.), gilt over gesso. One of a pair, the other is on the west side of the Chapel.

AT RIGHT, OPPOSITE THE DOORWAY: large **canopy** and red velvet **dossal** (Italian, probably Rome, 1560–70), purchased from Belisaris, Rome, 1895, through Ralph Curtis. From an interpretation of the armorial motif at the top, Adolph Cavallo has suggested that the *C* and *F* refer to Fabrizio Colonna, nephew to Pius IV (represented by the arms). IN FRONT OF THE CANOPY: marble relief of the *Madonna and Child*, by a 19th-century **imitator of Antonio Rossellino** (Florentine, 1427–1478); possibly the work of Giovanni **Bastianini** (Italian, 1830–1868), purchased from George Donaldson, London, 1888, as a work by Rossellino. BELOW IT: red cut voided velvet **garment fabric** (Turkish, 1600–1700) shot with gilt yarns. OVERHEAD, TO THE RIGHT: Spanish silver **hanging lamp**, with an inscription giving the date *1602* and naming the donors. FLANKING THE CANOPY AND RELIEF: two Empire–style **candlesticks**, appearing to be Spanish, but probably Italian, 19th century. A gift from Theodore Dwight, Christmas 1890, they were acquired from the Church of La Purissima, near Santa Barbara, California, in 1871.

CONTINUING TO THE RIGHT: *prie-dieu* (North Italian, second half of the 17th c.), inlaid with satinwood, mahogany, and burl walnut. ON IT: **processional cross** (Spanish Gothic), silver gilt and enamel, said to have come from Burgos Cathedral.

ON THE WALL TO THE RIGHT: *The Madonna and Child*, ca. 1494–97, tondo relief in terra cotta, by **Benedetto da Maiano** (Florentine, 1442–1497), purchased from Stefano Bardini, Florence, 1899. The frame is modern.

UNDER THE TONDO, THE *PRESIDENTS AND STATESMEN CASE*: **letters** and **autographs** of thirteen U.S. presidents: Washington, John Adams, Madison, Monroe, John Quincy Adams, Jackson, Tyler, Taylor, Fillmore, Grant, Cleveland, Theodore Roosevelt, and Taft. There are also letters and autographs of others, including: Benjamin Franklin, John Randolph of Roanoke, Aaron Burr, Francis Scott Key, Daniel Webster, and Jefferson Davis. In the back of the case are two Central African **arrows**, given to Isabella Gardner by A. Mounteney Jephson, who collected them when he joined Henry Stanley's 1871 expedition to rescue the Scottish missionary explorer David Livingstone in Ujiji.

ON A PEDESTAL TO THE RIGHT: glazed white terra-cotta bust of a *Young Girl*, ca. 1860, possibly by Giovanni **Bastianini** (Italian, 1830–1868), purchased from Duveen Brothers, 1910, through Berenson, as a 15th-century portrait of Maria Strozzi by Desiderio da Settignano and Luca della Robbia. The present attribution to Bastianini is that of John Pope-Hennessy.

The four **columns** below the archway are *marmo di persica* (peach marble), purchased in Venice, 1900.

OPPOSITE WALL: *A Young Lady of Fashion*, by **Paolo di Dono Uccello** (Florentine, 1397–1475), purchased from Böhler and Steinmeyer, New York, 1914, as a work by Domenico Veneziano. BELOW: small **chest of drawers** (Bassano, near Venice, 18th c.), pine veneered in walnut and mahogany.

TO THE RIGHT: *The Lamentation*, glazed polychromed terra-cotta relief, by Giovanni **della Robbia** (Florentine, 1469–1529) **and workshop**, purchased from Rev. Dr. Nevein, Rome, 1899, through Richard Norton. The inscription is from Lamentations I:12—"Oh all ye that pass by, behold and see if there be any sorrow like unto my sorrow." BELOW THE RELIEF: strip of **velvet brocade** (Italian, 1475–1525). Sargent used the design of this textile as the background for his 1888 oil portrait of Gardner (see the Gothic Room, p. 121). FLANKING THE RELIEF: pair of iron **torchères** (Venetian, 18th c.).

TO THE RIGHT, BESIDE THE DOORWAY TO THE TITIAN ROOM: walnut **cupboard** (Italian, made from several pieces, appearing 16th c.); on it is a marble **torso** (Graeco-Roman, Julio-Claudian period), purchased in Rome.

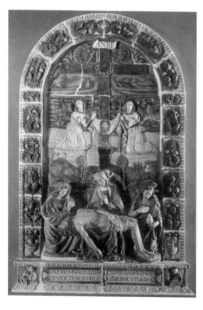

The Lamentation,
by Giovanni della
Robbia and his
workshop.

➤ CONTINUING IN THE LONG GALLERY,
 BEYOND THE MOORISH ARCHWAY:

Long Gallery, Middle Section

FOLLOWING THE COURT SIDE OF THE GALLERY ALL THE WAY DOWN:

INSIDE THE *ROYAL AUTOGRAPHS CASE*: **letters** and **documents** bearing the autographs of Ferdinand and Isabella of Spain, Sir Francis Bacon, François I, Cardinal Mazarin, Maria Theresa, the Marquise de Pompadour, Louis XVI, Marie-Antoinette, Bismark, and others. ABOVE THE CASE: marble **herm** of a *Greek Scholar or Man of Affairs* (Graeco-Roman, copy of a work of ca. 320–280 B.C.), purchased through Richard Norton, 1901. Supposedly found in Rome near S. Saba on the Aventine, 1901.

HIGH ON THE WALL: large painted wood **escutcheon** (German, late 16th c.), probably made for a castle banquet hall. The nine crests and twenty-one shields represent most of the reigning houses of what was to become modern Germany. A gift of Sir Henry Irving, 1902.

LEFT, NEAR THE COURT WINDOW: tall glass **cabinet**, framed with gilt woodwork, containing Medieval and Early Renaissance religious articles, most purchased in Munich, 1897. TOP SHELF: Limoges polychromed enamel **pyx** and **reliquary** (both 14th c.); silver **monstrance** (15th c.); standing under a canopy is a tiny **figure** of a monastic saint, probably Saint Dominic. SECOND SHELF: gilt **processional cross** (Spanish, 15th c.); on the arms are **half-figures** of the Virgin and Saint John. BOTTOM SHELF: gilded **chalice** (15th c.); gilt copper **monstrance** (German, 16th c.), with small figures of Saints Bartholomew and James Major.

BEYOND THE WINDOW: small **desk-case,** containing *Memoriae* from 15th-century French Books of Hours, including *Miniatures* **attributed to Jean Bourdichon** (French, ca. 1457–1521) [brown box] and thirty-seven *Miniatures* said to have been made for Anne de Bretagne (1477–1514) [blue, book-

shaped box]. The tooled leather cover contains a number of leaves illuminated by Andreas **Andersen** (Norwegian-American, 1869–1902); the heart-shaped silver **box** is Spanish, a gift of Denman Ross in 1921, containing a polychromed gesso Madonna. ABOVE THE CASE: gilt metal **crucifix** (French, 13th–14th c.) and three framed **illuminated initials** from antiphonals (North Italian, mid-14th c.), of saints Martin, Laurence, and Michael.

HIGH ON THE WALL: two green velvet **copes**: the large pomegranate pattern is Italian, 1500–1525; the small pomegranate pattern is Italian, 1475–1525. BELOW: painted carved wood **frieze** (Burgundian, early 16th c.), from a mantlepiece with two pages holding a banner inscribed *De Absentibus nil nisi bonum* (Of the absent, nothing but good). BETWEEN THE CASES: two carved and inlaid **armchairs** (North Italian, early 18th c.).

IN THE SECOND **DESK-CASE**: three Limoges enamel **plaques**: *The Madonna and Child*, from the **workshop of Jean I Limousin** (French, ca. 1561–1610), purchased from the Comtesse de Reculot, 1895, through Fernand Robert. *Pietà*, of an earlier date, purchased from Consiglio Ricchetti, Venice, 1897. *The Entombment*, from the **workshop of Nardon Pénicaud** (French, ca. 1470–1542), **or Jean I Pénicaud** (French, active ca. 1510–1540), purchased from Julius Böhler, Munich, 1897. ON TOP OF THE CASE: *Virgin's Crown*, purchased in Cartagena, a gift of Dr. and Mrs. Samuel Mixter, 1921. From a church in Bogotá, Colombia.

ABOVE THE CASE: *Saints Jerome, Mary Magdalen, and Francis*, from the **studio of Paolo di Giovanni Fei** (Sienese, active 1369–1411); and *The Martydom of Saint Bartholomew,* by an **unknown painter** (Florentine, ca. 1375–1425).

BY THE TRIPLE WINDOW: bookcase containing fine **bindings** of rare editions of French and Italian literature, including those with the arms of Charles II; Cardinals Mazarin and Richelieu; Pope Gregory III; Henri's II, III, and IV; James II; Louis's XIII, XV, and XVI; and the Grand Dauphin, son of Louis XIV.

ON THE BOOKCASE: polychromed limestone **crowned head** (Netherlandish or Burgundian, ca. 1400), purchased from the Émile Peyre collection, Paris, 1897.

TO THE LEFT, THE *WHISTLER-SARGENT CASE*: **letters** and **photographs** of Whistler, Sargent, and Dennis Bunker; five sheets of pen and ink **sketches** for the *Peacock Room*; **correspondence** with Paul-César Helleu, Augustus Saint-Gaudens, Edwin Abbey, Paul Manship, and others. The bamboo **stick** was Whistler's; the medal of John Sargent, 1880, and Mildred Howells, 1897, are by Augustus **Saint-Gaudens** (American, 1848–1907); *Joan of Arc*, 1915, is by Paul **Manship** (American, 1885–1966).

BEYOND THE WINDOW: five **choir stalls** (North Italian, 15th c.). The back panels have intarsia work of the 16th century, and they are scratched with old graffiti. Five more stalls from the original set are in the Gothic Room, p. 118.

ABOVE THE CHOIR STALLS: **tapestry**, *Melintus and Ariane Fleeing from Rome* (probably Flemish, 1675–1710). The tapestry is based on an engraving after Claude Vignon by Abraham Bosse that appears in a 1639 edition of Jean Desmarets de Saint-Sorlin's romance, *Ariane*, 1632, based on the life of the queen of Syracuse during the reign of Nero.

BEFORE THE CHAPEL, THE *MODERN ACTORS AND AUTHORS CASE*: Left side: **letters** and **photographs** to Isabella Gardner from Sarah Bernhardt, Paul Bourget, Coquelin, Yvette Guilbert, Walter Mapden, Sir Henry Irving, and Ellen Terry. Right side: **letters** of Voltaire, Rousseau, George Sand, Victor Hugo, Jean François Millet, Edmond and Jules de Goncourt, Huysmans, Bergson, and Verlaine. ON THE CASE, LEFT: *A Spanish Madonna*, ca. 1879–95, by John Singer **Sargent** (American, 1856–1925); inscribed to Isabella Gardner, it was probably a gift.

ON THE WALL ABOVE: oval embroidered **cartouche** or applied work motif (Italian, 1550–1600). RIGHT: *Madonna and Child*, painted terra-cotta tondo, from the **workshop of Benedetto**

da **Maiano** (Florentine, 1442–1497), purchased from Mariano Rocchi, Perugia, 1903, through Joseph Lindon Smith. BESIDE THE TONDO: ornate carved **frame** (Venetian, probably 17th c.), purchased in Venice through Edith Bronson, probably 1897. IN THE FRAME: silk cut voided velvet **garment fabric** (Italian or Spanish, 1600–25).

RETURNING TO THE ARCHWAY AND FOLLOWING THE OPPOSITE (EAST) WALL ALL THE WAY DOWN:

INSIDE OF THE "CONTEMPORARY" AUTHORS CASE: **letters** and **autographs**, including those of Robert and Elizabeth Barrett Browning, Thomas Carlyle, Charles Dickens, Edward VII, George Eliot, Henrik Ibsen, Christina Rossetti, John Ruskin, John Addington Symonds, Alfred Lord Tennyson, William M. Thackeray, and Oscar Wilde. The **rose** is from Robert Browning's funeral bier, and the moonstone **pendant** contains a lock of his hair. ON EITHER SIDE OF THE CASE: two carved and inlaid **armchairs** (probably North Italian, 17th c.). ON THE WALL ABOVE: candle **bracket** (Italian, 17th c.), one of four in the gallery.

TO THE RIGHT, THE "MODERN" PAINTERS AND SCULPTORS CASE: **letters** to Isabella Gardner from Boris Anisfeld, Cecilia Beaux, Ralph Curtis, Louis Kronberg, John La Farge, Dodge Macknight, Paul Manship, Joseph Lindon Smith, and Anders Zorn. The case also contains a **walking stick** of La Farge and **photographs** of Zorn. ABOVE THE CASE: marble **herm** of *Dionysos* (Graeco-Roman, ca. 50 B.C.–125 A.D.; reworked later, probably North Italian, 13th c.).

ON THE WALL ABOVE: *Battista Countess of Urbino* (1446–1472), late 18th or 19th c., **copy after Piero della Francesca** (Umbrian, ca. 1416–1492), purchased from the Galleria Sangiorgi, Rome, 1895, as a 15th-century copy. Original in the Uffizi, Florence. *Nursing Madonna and Child*, 19th c., **copy after Bernardino Luini** (Milanese, died 1532), purchased from Beneziani, Florence, 1903, through Joseph Lindon Smith at the

recommendation of Charles Loeser as a work by Luini. Original in the Ambrosiana Gallery, Milan. *A Procurator of San Marco*, late 16th c., **copy after Tintoretto** (Venetian, 1518–1594), purchased from Charles Eliot Norton, 1905. A contemporary copy of a three-quarter length portrait in the Staatliche Museen, Berlin. *The Adoration of the Kings*, by Joseph Lindon **Smith** (American, 1863–1950).

TO THE RIGHT, IN THE *ENGLISH AUTHORS CASE*: **autographs**, **letters**, **documents**, and **manuscripts**, including letters of Robert Burns, Johann Schiller, Sir Walter Scott, Thomas Hood, and Walter Pater (to Gardner); autographs of Ben Jonson, Charles II, Samuel Pepys, and Thomas Campbell; and manuscripts of Shelley's sonnet "To the Nile" and Keats's *Robin Hood*.

TO THE RIGHT: **cinerary urn** (Roman, early Imperial period). ON IT: **head of a youthful divinity (?)**, marble (Graeco-Roman, in the Severe style, ca. 465 A.D.)

ABOVE: **tapestry**, *God Shows Noah a Rainbow* (Flemish, Brussels, 1650–75), with the mark of Jasper **van Brugghen** (Flemish, active 1640–1655), purchased from L. Marcotte & Co., New York, 1880. The Latin inscription translates: "God Shows Noah the Rainbow as a Covenant." This is the third in the series (see Second Floor Stair Hall, North, p. 52, and Third Floor Stair Hall, South, p. 125).

BELOW: walnut high-back **sacristy bench** (Italian, in the style of the 17th c.). ON TOP, LEFT TO RIGHT: four small **reliefs**: *Standing Bishop on an Arcade* (North Spain, first quarter of the 15th c.), alabaster, purchased from the Émile Peyre collection, Paris, 1897; *Madonna and Child*, ca. 1480, polychromed stucco fragment, from the **workshop of Antonio Rossellino** (Florentine, 1427–1478), purchased from M. Guggenheim, Venice, 1892; *Man of Sorrows* (Umbrian, 16th c.), terra cotta, purchased from Mariano Rocchi, Perugia, 1903, through Joseph Lindon Smith; and *Saint Laurence* (Italian, 15th c.), limestone.

TO THE RIGHT: **cinerarium** (Roman, 1st–2nd c.), purchased through Richard Norton, Rome, 1901, said to be from near San Paolo fuori le Mura, with an inscribed plaque naming a Greek freedman. ON IT: marble **bust of a man** (Roman, style of ca. 150 A.D.)

BY THE WINDOW, IN THE *MARY QUEEN OF SCOTS CASE*: a fragment of green **satin** and one of Flemish mixed **lace** reputed to have belonged to Mary Stuart; her **Book of Hours**, printed at Paris in 1514 on vellum, with woodcuts and illuminated initials. The **manuscript** *The Form and Manner of Keeping the Parliament of England*, probably written in 1558–59 for Thomas Howard, fourth duke of Norfolk and earl marshal of England from 1554 to 1572. ***Essays of Sir Francis Bacon***, printed at London in 1612, with the arms of James I stamped on both covers and with marginal notes in the king's own hand.

AT THE RIGHT, THE *DANTE CASE*: three early editions of the **Divine Comedy**: the Landino commentary of 1481 with nineteen engravings after designs by Sandro **Botticelli** (Florentine, 1445–1510); the Brescia copy of 1487, with sixty-eight woodcuts; and the Aldine edition of 1502, the first book to bear the printer's famous mark, an anchor around a dolphin. Also, a collection of eighteen **manuscripts** (Venetian, 16th–18th c.) and **letters** of Vittoria Colonna; Roberto Malatesta; Federico, the duke of Urbino; and Ludovico Maria Sforza, the duke of Milan. ON THE BOOKCASE (see Yellow Room, p. 19): two limestone **half-figures** from a choir rail: the *Virgin* and the *Angel Gabriel*, ca. 1500, by Giovanni Antonio **Pilacorte** (Venetian, ca. 1455–1531), purchased from Consiglio Ricchetti, Venice, 1890.

ABOVE: *The Madonna and Child Enthroned with Saints Francis, John the Baptist, John the Evangelist, Mary Magdalene, Clare, Catherine, Agnes, Lucy and Donors,* tempera transferred to modern panel, signed and dated *1307* by **Giuliano da Rimini** (Riminese, active 1307–1346). From the cathedral at Urbania, Marches, it was purchased in London, 1903, through Joseph Lindon Smith.

Chapel

The most southerly third of the Long Gallery is a small Medieval chapel in which, on Isabella Gardner's birthday, April 14, an Anglican high mass is celebrated at her request.

FLANKING THE ENTRANCE: on staves set into stone imposts, two painted copper **lanterns** (Venetian, 17th–18th c.), with quartz panes; and two low **stalls** (French, 15th c.).

BY THE WINDOW, LEFT: upholstered **church chair,** a 19th-century Italian version in *lignum vitae* of a late 18th-century French *voyeuse* (spectator's chair), also used as a *prie-dieu*. ABOVE THE WINDOW: painted wood **Madonna with a King and Bishop** (Franconian, mid-17th c.).

OPPOSITE: *prie-dieu* (Italian, 17th c.), walnut, with mother-of-pearl inlay. ABOVE, ON THE WALL: *The Wedding Feast at Cana,*

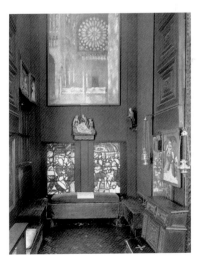

The Chapel alcove, with Paul-César Helleu's *Interior of the Abbey Church of Saint Denis,* and two 16th-century Milanese stained-glass windows.

ca. 1545, by Jacopo Robusti, called **Tintoretto** (Venetian, 1518–1594), purchased from Charles Eliot Norton, Boston, 1905.

LEFT: tall bronze **candlestick** (Italian, 15th–16th c.), one of the four in the Chapel; range of two walnut **choir stalls** (Italian, 16th–17th c.); gilt and painted wood **standing lanterns** (Italian, probably 15th c.). The **figure** inside the one by the doorway is possibly Saint Nicholas (Bavarian, 16th c.).

ABOVE THE DOORWAY: wood **relief** of *Saint Margaret* (Bavarian or Tyrolean, ca. 1520–30), purchased from Theodor Einstein & Co., Munich, 1897. BEYOND THE DOORWAY AND AROUND THE ALTAR: set of fifteen walnut **choir stalls** (Italian, 16th c.), purchased from Giuseppe Piccoli, Venice, 1900, through Daniel Sargent Curtis. From a monastery in the Veneto.

ON THE WALL NEAR THE ALCOVE: linden wood **statue** (German, possibly Upper Rhenish, ca. 1500–10) of *Saint Jerome*, purchased from Hermann Einstein, Munich, 1897.

IN THE ALCOVE, HIGH ON THE WALL: *The Interior of the Abbey Church of Saint Denis*, by Paul-César **Helleu** (French, 1859–1927), purchased from the artist, Paris, 1892, through John Singer Sargent. BELOW: painted oak *Pietà* (Rhenish or Netherlandish, ca. 1500); pair of Milanese **stained-glass windows**. LEFT: *Ruth and Boaz (?)* (Ruth 2–4), ca. 1549–57. RIGHT: *The Judgment of Solomon* (1 Kings 3:16–28), ca. 1544/45, purchased from A. Pickert, Nuremberg, 1875. IN FRONT: large iron **candelabrum** (probably Italian, 15th c.).

ON THE WALL TO THE RIGHT: *The Annunciation*, by an **unknown painter** (South German, provincial, ca. 1450–1500), probably purchased from Theodor Einstein & Co., Munich, 1897. BELOW: *prie-dieu* (North Italian, 16th c.). TO THE RIGHT, ON A LECTERN: **leaf from a choir book** (Italian, 15th c.), gift of Denman Ross, Christmas 1921. Written for Saint Laurence's Day.

ABOVE THE STALLS TO THE LEFT: wood **figures** of *Saint James* (Franconian, ca. 1480); *The Virgin* (Swabian, ca. 1480); *Saint John* (Swabian, ca. 1480), and a *Kneeling Virgin* (Franconian, ca.1440–50).

AT THE END OF THE HALL, OVER THE ALTAR: **stained-glass window** (Soissons Cathedral, first decade of the 13th c.), depicting scenes from the lives of saints Nicaise and Eutropie, purchased from Bacri Frères, Paris, 1906, apparently on the advice of Henry Adams. ON THE ALTAR BELOW: the **altar frontal** is 15th-century Sicilian drawnwork; the **superfrontal** is a strip of darned netting (Sardinian [?], 16th c.). BEHIND THE ALTAR, LEFT AND RIGHT: wood **figures** (Ulm, ca. 1500) of *Saint John* and a *Female Saint*.

IN THE CORNER TO THE RIGHT: *Saint Filippo Neri*, by an **unknown painter** (Roman, late 16th or 17th c.).

ON TOP OF THE STALLS, RIGHT: eight **saints** (Bavarian, ca. 1510–1520), of polychromed wood, from an altar shrine. Those with attributes have been identified as Paul, Stephen, Barbara, Agnes, and Dorothea. The other three may be Catherine, Peter, and Laurence.

➤ THROUGH THE DOORWAY:

Third Floor Elevator Passage

ON THE DOOR: small carved **cupboard door** (French, 13th–14th c.), purchased from the Émile Peyre collection, Paris, 1899. TO THE LEFT, IN THE LARGE CASE: *Listening to the Lute*, six-fold **screen** (Japanese, Kanō school, 17th c.), purchased at the Bunkio Matsuki sale, Boston, 1901. The screen depicts Chinese gentlemen and their servants relaxing on a mountainside.

OPPOSITE WALL: *The Tale of the Genji*, 1677, pair of six-fold **screens**, with the seal and signature of Fujiwara **Tsunenobu**

A scene from *The Tale of the Genji*, Japanese,
dated 1677 and signed by Fujiwara Tsunenobu.

(Japanese, Kanō School, 1636–1713), provenance unknown.
The screens show scenes from the romantic novel about
Prince Genji, written ca. 1000 by Lady Murasaki. BELOW:
Pheasants and Small Birds, six-fold **screen** (Japanese, Kanō
school, late 17th–18th c.), purchased from the Bunkio Matsuki
sale, Boston, 1902. IN FRONT: oak **chest** (American, ca. 1675),
carved with palm-leaf panels (front) and seven rosettes (draw-
er). Beside it is a walnut **sacristy bench** (Castilian, 17th c.) with
a reclining back.

TO THE RIGHT OF THE DOOR: two **hanging scrolls** (Chinese,
Ming dynasty): *Wild Geese*, ca. 1459–1519, color on silk, signed
Yü Ta of Shih-hsi; and *Peonies and Ducks*, ca. 1500, color on silk.

ABOVE THE ELEVATOR DOOR: **hanging scroll** (Chinese, Ming
dynasty, middle of the 15th c.), *Pheasants*, color on silk.
ENCLOSING THE ELEVATOR: four carved and gilt **doors** (Chinese,
late 19th c.), acquired in China with the doors on the floor
below (see p. 82) through Joseph Lindon Smith, 1909/10.

Gothic Room

The entrance doorway leads through a carved oak **tambour** (Northern French, ca. 1500), purchased from the Émile Peyre collection, Paris, 1897. This might have divided a spiral staircase from a room or covered a doorway. ABOVE THE TAMBOUR: *The Madonna and Child*, by an **unknown painter** (Venetian, ca. 1425–1475), purchased from Consiglio Ricchetti, Venice, 1897. TO THE RIGHT: *The Madonna and Child with an Apple*, round-arched panel painting, by an **unknown painter** (North Italian, ca. 1430–1480). BELOW: **armchair** (Italian, 17th c.). In front of the tambour is a **child's chair** (Italian, early 17th c.) and a caned **daybed** (English, late 17th c.).

HANGING HIGH ON ALL THE WALLS: **frieze** (North Italian, 15th c.) of sixty-eight paintings, portraits of people of the Renaissance. Several panels repeat, some in different poses. Purchased in Venice, some from Antonio Marcato, 1888, and the rest from Dino Barozzi, 1899.

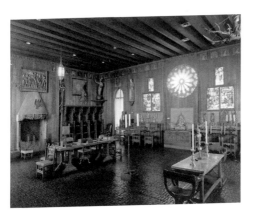

The Gothic Room, looking toward the Southeast corner.

The **fireplace** is Venetian, in the style of the 15th c., purchased from Francesco Dorigo, Venice, 1899; the **andirons**, with ecclesiastical figures in relief, and the **fireback** are French, 15th c., purchased from the Émile Peyre collection, Paris, 1897. On the fireplace canopy, in iron, are the arms of the Catholic kings, ca. 1493–95. Purchased from Villegas, Rome, 1895, and originally from the Church of San Juan de los Reyes, Toledo.

ON THE FIREPLACE: **altarpiece** (Upper Rhenish or Swiss, 1515), *Saint Maurice and the Theban Legion*, purchased from Charles Rafard, Paris, 1892. IN FRONT OF THE FIREPLACE: two **children's chairs** (Italian, early 17th c.); FLANKING THE FIREPLACE: two large French Gothic gilt iron **torchères**, purchased from the Émile Peyre collection, Paris, 1897. TO THE RIGHT: walnut **armchair** (Italian, 17th c.). HANGING FROM THE CEILING NEAR THE FIREPLACE: wrought-iron **lantern** (Italian, 15th c.).

ALONG THE REST OF THE WALL: **choir stalls** (North Italian, 15th c.), from the set in the Long Gallery (see p. 109). ABOVE THE CHOIR STALLS, LEFT TO RIGHT: life-sized wood **figure** (Lower Rhenish, early 16th c.) of a magus, also from the Émile Peyre collection, Paris, 1899; to the right is a wooden **figure** (South German, ca. 1470–80) of a mounted saint, perhaps *Saint Hubert* or *Saint Eustace*, purchased from Julius Böhler, Munich, 1897; above is a two-pointed embroidered **pennant** (Spanish, 1592–1605), purchased from Villegas, Rome, 1895. Datable by the coat of arms to the reign of Pope Clement XVIII, the flag is inscribed with the name of the town of Almodóvar del Campo, in south central Spain. HIGH IN THE CORNER: brass (?) **figure** (Venetian, 19th c.) of the *Angel Gabriel*, purchased from Antonio Carrer, Venice, 1892, who told Gardner that the bullet hole in the angel's chest was from shelling during the *Risorgimento*.

SOUTH WALL, LEFT TO RIGHT: leather upholstered **armchair**, from the set in the Tapestry Room (see p. 78); oak **credence** (French, style of the 14th c., mostly 19th-c. construction with some old parts); on it is a painted terra-cotta **bust** (Italian,

1615–1715) of a *Dominican Nun*, purchased from Emilio Costantini, Florence, through Joseph Lindon Smith.

HIGH UP: **Saint Agnes** (Italian, probably Spoleto, second quarter of the 14th c.), purchased from the Émile Peyre collection, Paris, 1899; CENTER: a stone **wheel window** may be Italian, 15th c., acquired from Saturnino Innocenti, Rome, 1897; AND TO THE RIGHT: **Saint Agnes** (Aquila, ca. 1315), acquired from Stefano Bardini, Florence, 1897.

THE STAINED GLASS:

A group of six **stained-glass windows**. The upper pair are Austrian, ca. 1480–90. They were made to commemorate the marriage between A. Lienhard Jöchl (left) and Dorothea Hungerhausen (right). The four lower windows are from Milan Cathedral and illustrate, from left to right: *The Vision of Saint John* (ca. 1420; from Apocalypse 4); *Christ Washing the Feet of the Disciples* (ca. 1480–90); and two scenes from the life of Saint John of Damascus (after 1480). All of the windows were acquired from A. Pickert, Nuremberg, 1875.

BELOW THE WHEEL WINDOW: carved walnut **chest** (French, ca. 1525), purchased from the Emile Gavet collection, Paris, 1897, through Fernand Robert. The front panels depict the Madonna and Child with saints Claude, John the Evangelist, Barbara, and Nicholas. ON THE CHEST: painted stucco *Madonna and Child*, from the **workshop of Lorenzo Ghiberti** (Florentine, 15th c.), purchased from the Emile Gavet collection, Paris, 1897, through Fernand Robert, as a work by Jacopo della Quercia. Flanking it are a pair of brass **candelabra**, probably German. ON THE WALL TO THE LEFT AND RIGHT OF THE CHEST: wood **jambs from a door frame** (probably French, early 16th c.), purchased from the Émile Peyre collection, Paris, 1897. The small carved groups tell the story of Mary's parents, Joachim and Anne (*The Golden Legend*, 13th c.).

AT THE LEFT: two **armchairs** from a set of four in the room (North Italian, ca. 1600), carved walnut also inlaid with walnut;

wrought-iron **candelabra** (Spanish, 16th c.), with the arms of the Bishop of Toledo.

On the shelf to the left: gilt and polychromed wood **figure** (Austrian or North Italian, ca. 1425) of the *Enthroned Virgin and Child,* purchased from Stefano Bardini, Florence, 1897. Once part of an *Adoration of the Magi.* Two gilt wood **angels** (Italian, 15th c.) supporting candles. On the wall: **garment fabric** in the form of a cope (Italian or Spanish, 1550–1600).

To the right of the chest: three walnut **chairs** (Italian, 17th c.), purchased from Emilio Costantini, Florence, 1897. Once in the Albergotti Palace at Arezzo, heavy chairs of this type were architectural treatments along the walls of baroque palaces. Above the chairs, on the shelf: **gabled shrine** (Italian, the Veneto, second half of the 15th c.) with the *Virgin and Child.* The four gilt and painted **angel candlesticks** are Italian, 17th century.

To the right: iron **torchère** (Spanish, ca. 1400) and iron **lectern** (probably French, 15th c.). On the lectern is a pigskin **book cover** with brass mountings. The torchère and the book cover were purchased from the Émile Peyre collection, Paris, 1899. The oak **credence** (French, ca. 1450, but largely restored) supports a painted gilt stucco **bust** (Italian, 19th c.) of a woman. Both purchased from the Emile Gavet collection, Paris, 1897, through Fernand Robert, as 15th-century works.

In the corner: oak **chest** (Spanish, 15th c.), purchased from Galeries Heilbronner, Paris, 1906. The front sides and lid are all made from single planks of wood. The coat of arms of Rodrigo de Velasco, Bishop of Palencia (died 1485), is on the front. On the chest: leather-bound **choir book** (Italian, mid-17th c.), gift of George A. Gardner. A late example of manuscript illumination, this is an *antiphonarium* and contains music for the hourly prayers as well as the principal feast days. The colophon is signed by the copyist Brother Jerome.

Behind, on an easel: *Isabella Stewart Gardner,* 1888, by John

Isabella Stewart Gardner, 1888, by John Singer Sargent.

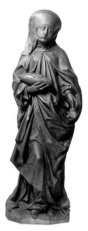

Saint Elizabeth of Hungary, linden wood, Upper Rhenish or Swabian, ca. 1490.

Singer **Sargent** (American, 1856–1925), commissioned from the artist and painted in Gardner's home on Beacon Street, Boston. A textile now displayed in the Long Gallery (see p. 106) was used for the background. ON THE WALL BEHIND THE PORTRAIT: **tapestry**, *The Landlord and the Woodcutters* (Flemish, probably Tournai, ca. 1510–20), probably purchased from Charles Rafard, Paris, 1892.

BY THE WINDOWS, ON AN EASEL: *The Madonna and Child with Saints and a Donor*, by **Simone Martini** (Sienese, ca. 1283–1344), purchased from Stefano Bardini, Florence, 1897, as a work by Lippo Memmi. IN FRONT OF THE EASEL: **peasant chair** (North Italian, provincial, 17th c.).

ON THE OPPOSITE SIDE OF THE EASEL: *The Presentation of the Infant Jesus in the Temple*, by **Giotto di Bondone** (Florentine, 1267–1336/ 37), purchased from J. P. Richter, London, 1900, through Berenson. Depicting the story in Luke 2, this is one of seven surviving panels from a series of scenes of the life of Christ. IN FRONT OF THE EASEL: *"Dante"* style **chair** (Italian, 16th c.).

BEYOND THE WINDOWS: two ends of a **stall** (French, provincial, ca. 1400), used here in the form of a bishop's throne and supporting a canopy, made from pieces acquired from the Émile Peyre collection, Paris, in 1897 and 1899. Above it is a linden wood **statue** (Upper Rhenish or Swabian, ca. 1490) of *Saint Elizabeth of Hungary*, purchased from Antonio Carrer, Venice, 1893.

SPANNING THE CORNER BY THE DOORWAY: **tapestry**, *The Education of the Prince of Peace* (Flemish, probably Tournai, 1525–50), purchased from Galerie de l'Universelle, Paris, 1892. The young prince stands in the foreground surrounded by allegorical figures, carefully labeled. The arms in the upper corners are probably those of François de la Viefville and his wife Anne de Neufville. ABOVE THE DOORWAY: *Saint Thomas Receives the Madonna's Girdle*, polyptych, by an **unknown painter** (Ligurian, ca. 1450–1500), purchased from Giuseppe Piccoli, Venice, 1899. ACROSS THE TOP OF THE DOORWAY: carved **beam** (French, probably 14th c.).

TO THE RIGHT OF THE DOORWAY: Spanish *bargueño* (portable desk), walnut, restored in the style of the 17th century. ON IT: painted terra-cotta **bust** (Tuscan, last quarter of the 15th c.) of *Saint Bernardino of Siena*, purchased from Stefano Bardini, Florence, 1897. Thermoluminescent testing in 1973 and 1975 confirmed its dating. ABOVE: *Adam and Eve,* ascribed to a **follower of Lucas Cranach the Elder** (German, 1472–1553), purchased from a Venetian family, 1892, on the recommendation of Prince Friedrich Hohenlohe, through Katharine de Kay Bronson.

BY THE COURT WINDOWS: four walnut **armchairs** (probably Sicilian, 17th c.). BETWEEN THE WINDOWS: carved **triptych** (Saxon, ca. 1510–1520), painted linden wood, purchased from the Emile Gavet collection, Paris, 1897, through Fernand Robert. The central panel is devoted to the Holy Kinship (*Die Helige Sippe)* and depicts Saint Anne with her three husbands, three daughters, sons-in-law, and grandchildren. She and her daughter, the Virgin Mary, help support the Infant Christ. On the wings are four carved female saints. BELOW: oak **credence** (French, ca.

1500), purchased from the Émile Peyre collection, Paris, 1897.

HIGH ABOVE: polychromed limestone **Madonna and Child** (Île-de-France, mid-14th c.), purchased from the Émile Peyre collection, Paris, 1899; and fragments of a *millefleurs* **tapestry** (Flemish, 1475–1550), purchased from Julius Böhler, Munich, 1897.

BY THE DOUBLE COURT WINDOW: wrought-iron **reading stand** (French, ca. 1300), purchased from the Émile Peyre collection, Paris, 1899; five silver **plaques** (Italian, 14th c.), purchased from M. Guggenheim, Venice, 1897. Mountings from a book or a crucifix, they depict a bishop, Lazarus rising from the tomb (?), and the symbols of the Evangelists, saints Mark, Luke, and John.

BEYOND THE WINDOWS, HIGH ON THE WALL: *Altar of the Trinity with Saint Catherine and a Bishop Saint* (North German, Lübeck, ca. 1510–20), **attributed to the circle of Bernt Notke** (North German, active ca. 1490–1520), the Lübeck master. Purchased from Hermann Einstein, Munich, 1897.

ON THE SIDEBOARD BELOW: two brass **plates** (one French, one German); a pair of brass **candlesticks** (Italian, 16th c.); a brass-bound leather-covered **liqueur chest** (Italian, 17th c.), engraved with the arms of the Leze family of Venice; and two copper cooking **molds**. The lace **cover** is Spanish darned netting, trimmed with a bobbin lace of Russian type.

OUT IN THE ROOM, NEAR THE FIREPLACE: walnut **refectory table** (Italian, 16th c.). ON THE TABLE: **chained book**, *Sermons of Johann Nider*, printed by Conrad Fyner at Esslingen in 1476–78. Both the binding and the chain are original. Originally from the Carmelite monastery of Bamberg, it was purchased from G. Michelmore & Co., London, 1923. ALSO ON THE TABLE: **coffer** (Venetian, 17th or 18th c.), inlaid with mother-of-pearl, purchased from Moisè dalla Torre & Co., Venice, 1899; small embossed-leather **coffer** (Italian, possibly 14th c.) with a curved lid; lead **box** (French, Gothic, 14th c.), purchased from the Émile Peyre collection, Paris, 1899; and a **scepter** (Persian or

Kashan, ca. 1800) with a bull's head. The **chairs** around the table are Italian, ca. 1600.

BETWEEN THE TABLES: iron **candle stand** (French, 14th c.), called *couronne de fer* (iron crown), purchased from the Émile Peyre collection, Paris, 1897. TO THE WEST: **table** with a top of *cipollino rosso* marble, purchased from Francesco Dorigo, Venice, 1899, and made into the table. ON THE TABLE: gilt metal **processional cross** (Italian, provincial, 14th–15th c.), purchased from A. Pickert, Nuremberg, 1897. The brass **candlesticks** are Italian, 15th century. At the North end of the table is a "Savanarola" **chair** (19th c., in the style of a 16th-c. Italian type); at the South end is a "Dante" style **chair** (19th c., in the style of a 16th-c. Italian type).

HANGING FROM THE CEILING: **chandelier** (Bavarian, 16th c.), purchased from Theodor Einstein & Co., Munich, 1897. Made of two antlers and a painted wood kneeling figure.

➤ THROUGH THE DOORWAY:

Third Floor Stair Hall, South

ABOVE THE DOORWAY: wood **crucifix** (French or Spanish, 16th c.), purchased from the Émile Peyre collection, Paris, 1899, through Fernand Robert.

RIGHT: painted wood low-relief **figure** (Italian, Lombard, ca. 1500) of *Saint Peter Martyr*, purchased from M. Guggenheim, Venice, 1897, as a praying monk by Ambrogio Foppa Caradosso.

ON THE WEST WALL: *Entombment of Christ*, painted terra-cotta relief, by Giovanni **Minelli** (Paduan, ca. 1460–1527), purchased from Emilio Costantini, Florence, 1897, through Berenson as a work by Bartolommeo Bellano. The kneeling figure at the left is Carlotta, illegitimate daughter of James II, King of Cyprus. This relief was made for the altar over her tomb, ca. 1483, in the church of Sant'Agostino, Padua (demolished in 1829). The frame is modern.

ON THE FLOOR, RIGHT: marble **capital** (Venetian, 13th c.), with a 15th-century angel attached to one side. AGAINST THE WALL: oak **credence** (French, 15th c.), with a modern top, purchased from the Émile Peyre collection, Paris, 1897. ABOVE THE CREDENCE: pair of gilt and polychromed wood **retables** (Spanish or French, early 16th c.). Eighteen scenes from the life of the Virgin are carved in relief; they read from left to right and from bottom to top. Purchased from the van den Bogaerde collection, Bois le Duc, Netherlands, 1901, through Fernand Robert.

OPPOSITE THE MINELLI, TO THE RIGHT OF THE COURT WINDOW: **tapestry**, *God Commands Noah to Build the Ark* (Flemish, Brussels, 1650–75); the first in the set of three in this collection (see pp. 52 and 111). UNDER THE TAPESTRY: painted limestone **retable** (Provençal, dated 1507), purchased from the Émile Peyre collection, Paris, 1897, through Fernand Robert. The *Baptism,* the *Annunciation,* and the *Beheading of John the Baptist* are depicted. The coat of arms is that of Arnal de Serres of Languedoc, and the inscription probably translates: "This is completed and placed on the fifth day of August, 1507. Do not forget the dead."

TO THE LEFT OF THE WINDOW: wood **figure** (Catalonian, second half of the 12th c.) of *Christ from a Deposition Group,* purchased from Joseph Brummer, New York, 1917.

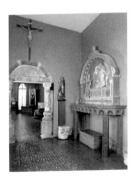

The Third Floor Stair Hall, South, looking toward the Gothic Room.

INDEX